# EUROPEAN
# FANS
## The Untold
## Story

This edition © Scala Arts & Heritage Publishers Ltd, 2022
Text, illustrations and photography © Eurus Collection, 2022

First published in Korean in 2018 by Eurus Collection

This English edition first published in 2022 by
Scala Arts & Heritage Publishers Ltd
305 Access House
141–157 Acre Lane
London SW2 5UA, UK
www.scalapublishers.com

In association with
Eurus Collection
39-11, Daesagwan-ro 3-gil
Seongbuk-gu, Seoul, South Korea

ISBN 978-1-78551-412-8

Written by Hahn Eura EunKyung and Dr HaYoung Joo
Translated by Sunee Hong Markosov
Translation copy-edited by Sandra Pisano
Designed and typeset by Peter Anthony Sutton
Cover designed by Matt Wilson
Photography by Seoul Kim
Printed in Turkey

10 9 8 7 6 5 4 3 2 1

Cover: Louis XIII-style painted fabric and ivory fan, Europe, late 19th century, 23 x 41 cm
© Eurus Collection

Pages 4–5: Ivory brisé fan, England, 1830, 15.5 x 26 cm © Eurus Collection

Pages 244–45: Painted vellum and mother-of-pearl fan, Europe, late 19th century, 29 x 53 cm
© Eurus Collection

# EUROPEAN FANS
## The Untold Story

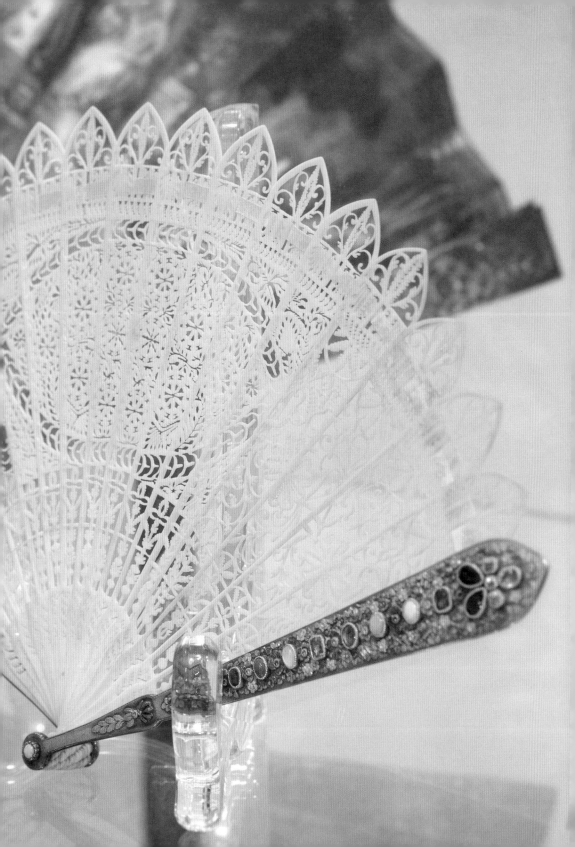

# Foreword

Eurus Collection was founded in 2017 to honour the wishes of my late father, Hwajeong (Dr.h.c. Hahn Kwang-ho). Eurus is one of the wind gods in Greek mythology, specifically referring to the god of the East wind. Like the East wind bringing rain on a warm and calm day, Eurus Collection was established with the intent to offer a breeze of fresh perspectives on the arts and culture. This book introduces a part of Eurus Collection, 66 carefully selected fans from Europe dating from the eighteenth to the twentieth century, categorised by theme, style and material.

Most of the works were collected by the late Hwajeong who, as the head of the Hahn Cultural Foundation, personally visited many classical arts sites both in Korea and abroad from the 1960s up until his passing. His vast collection ranges from Tibetan Buddhist artworks and traditional Chinese artefacts to European paintings and classical crafts, reflecting the societal, cultural, political and religious ideologies of both East and West. Hwajeong's passion for and appreciation of different cultures and traditions led his efforts in preserving cultural artefacts, and this pursuit was the most important part of his life. He was the first Korean honorary patron of the British Museum and was one of the key contributors to the establishment of The Korea Foundation Gallery at the Museum. In recognition of his contribution, he became a Commander of the Order of the British Empire (CBE), bestowed by The Queen in 1999. This book is specially written to commemorate Hwajeong's accomplishments and to celebrate his love and passion for the arts.

Traditionally fans were not merely functional items, but also served as symbols of class status and religious ritual. Moreover, as fashion items, fans served a decorative function, as well as being used as devices for discreet communication. Their practical, symbolic and aesthetic aspects make them worthy of recognition as sophisticated artworks.

Today, due in part to industrialisation and advancements in technology, fan usage has decreased. Fans still function as fashion items, but also stimulate our imagination, create a sense of nostalgia for bygone times and inspire new artworks. I hope this publication offers an opportunity to appreciate the artistic value of fans in their historical and cultural context.

**Hahn Eura EunKyung**
Director of Eurus Collection

# Contents

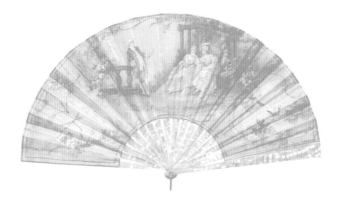

# Introduction

The purpose and the meaning of fans has been defined in various ways throughout history. Fans were not simply household items used to fend off the heat, but were also used for religious and ceremonial events. They acted as symbols of royal power and authority and served as important fashion accessories.

The use of fans dates back to ancient Egypt, Greece, Rome and Etruria, as well as ancient China, Korea and Japan. The oldest extant fan is considered to be the two flagella, partially made from feathers, which were found in the tomb of Tutankhamun (reigned 1361–1352 BC), an Egyptian pharaoh of the eighteenth dynasty. In ancient China fans appeared in myths and literature before the time of Yu the Great of the Xia dynasty (2070–1600 BC). In medieval Europe the flabellum of Monza, also known as "Queen Theodolinda's fan", dating from the sixth century AD, illustrates how fans were used for religious ceremonies.

▲ Fig 1. Tutankhamun's fan (the handle of an ostrich feather fan), The Museum of Egyptian Antiquities, Cairo, Egypt

This book focuses on European fans made in the French Rococo style in the eighteenth century and the Rococo Revival style that emerged in the nineteenth century. These fans offer a glimpse into the lives of European royalty and aristocracy, including their aesthetic preferences, ideals and views on nature. In addition, the fans demonstrate the intermingling of cultures in the newly emerging painting and craft styles which resulted from trade between Europe and the East.

The illustrations depicted on fan leaves are diverse in theme, ranging from history, mythology and religion to social customs and landscapes. Through careful investigation of these themes, it is possible to chart changes in tastes and preferences of fan owners. At the height of the Rococo style's popularity in Europe in the eighteenth century, production of fans increased greatly to meet the

▲ Fig 2. Fan types (clockwise from top left): fixed fan, folding fan, cockade fan and brisé fan, Eurus Collection

growing demand. In addition to being colourful, decorative objects, fans were used in a variety of ways to express their owners' thoughts and feelings.

As an extension of people's gestures, the non-verbal language of fans enabled elegant, sophisticated and private communication. Consequently fans became a must-have item for the upper classes and they reflected the customs and aesthetic requirements of the times. Their use and value would vary according to historical events and societal changes.

From a structural point of view, fans are primarily divided into three categories: fixed, folding and cockade. A fixed fan is usually round or square with a handle attached to its leaf. A folding fan refers to a fan that can be opened and folded. The folding fan has two types: a general folding fan, with separate sticks and leaf, and a brisé fan, constructed of individual sticks with a ribbon or threads connecting the top part. A cockade fan is round in shape when fully opened and has two handles which meet when the fan is in the folded or opened position. A wide range of materials, including ivory, tortoiseshell, mother-of-pearl, horn, feathers and bronze, were used to make fans, resulting in diverse decorative techniques and sizes.

**From fixed fans to folding fans**

In the East, fixed fans were used first in China and then spread to Japan through Korea. The influence of the Chinese fixed fans can be seen in the artworks of the region. For instance, Japanese paintings from the third to the sixth century depict fixed fans that are virtually identical to the Chinese fixed fans from earlier periods. Folding fans, on the other hand, are believed to originate from the Heian period (794–1185) of Japan. The spread

of folding fans is outlined in historical documents in the region. In the Goryeo period (918–1392) in Korea, the folding fan was called *Juil Buche* (쥘부채), which is literally translated as "hand grip fan", due to its portable nature. During the Song dynasty (960–1279) in China, it is recorded that around the eleventh century Korean envoys passed along Korean folding fans to China. Since then, through cultural exchange between the East and the West, fans have developed into many designs and styles.

The Eastern folding fans were first introduced to Europeans in Venice, the centre of Mediterranean trade, around the year 1500. Prior to this, traditional flag-shaped fans and feather fans were in use among Venetian noblewomen. The rare folding fans from the East were

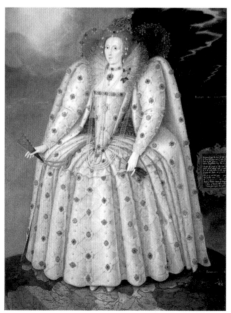

▲ Fig 3. Marcus Gheeraerts the Younger, *Queen Elizabeth I*, c. 1592, oil on panel, 241.3 x 152.4cm, National Portrait Gallery, London

treated as status symbols among the Italian aristocracy and eventually spread throughout Europe. Catherine de' Medici (1519–1589) originated the use of fans as a fashion accessory by introducing feather fans into the French royal family, which presaged a growth in popularity of various types of fans in France. In England, Elizabeth I (1533–1603) was also known to be a collector of fans. By the time she passed away in 1603 there were numerous fans listed in the official inventory of her wardrobe, some of which appeared in her portraits. While feather fans were shown in portraits from the early days of Elizabeth I's reign, a folding fan appeared in the later period. The fans were a symbol of the queen's royal status and authority.

In Europe after the sixteenth century the popularity of fans grew as they became important fashion items. By the seventeenth century fan styles were no longer limited to the initial folding fan designs, but expanded to encompass new styles such as the brisé and cockade. The fan leaves produced during this period featured subjects referencing mythology, history, classics and the Bible.

## Seventeenth- to eighteenth-century European fans

In the seventeenth century, guilds of fan-makers were organised to consolidate their fan-making expertise. In France a group of fan-makers gathered to form the *communauté des éventaillistes* (guild of fan-makers) and from 1678 a royal edict by Louis XIV (1638–1715) allowed them to operate as an independent profession.* These

---

* The *éventaillistes* (fan-makers) worked on fan leaves only. They decorated fan leaves by painting on them and ruffling them. They also worked on the sale and distribution of fans. Fan sticks and guards were made by other artisans such as *luthiers* and *tabletiers* (makers of small objects such as boxes or combs).

developments resulted in the relocation of the fan-making centre from Italy to France. However, Italy continued to produce high quality fans. In England "The Worshipful Company of Fan Makers" was incorporated in 1709 by a Royal Charter and began producing fans in an organised and professional manner. Meanwhile, in France, the abolition of the Edict of Nantes by Louis XIV in 1685 led to a mass emigration of the Huguenots, the French protestants who followed the teachings of John Calvin, to neighbouring countries. This migration included many skilled fan-makers as well as other artisans. Consequently, by the eighteenth century, most European countries were producing fans, and fan leaf painting became an important craft. Weddings and banquets were particularly popular themes in fan leaf production.

▲ Fig 4. Painted ivory folding fan, 18th century, 24 x 40.3 cm, presumed to be from Italy, Eurus Collection

The eighteenth century was the golden age of fans in Europe. What had once been rare and precious, exclusive to royal families and aristocrats, now became a fashion necessity for many social classes. In the French fans produced during the Age of Enlightenment, idyllic landscapes of an imagined countryside appeared as the main

subject for fan leaf paintings. In addition, as the Rococo style became fashionable, large and highly decorative semi-circular fans were introduced. Fan leaves made in Italy usually appropriated themes from ancient Greek and Roman history and mythology. These Italian fans were prized as Grand Tour souvenirs by wealthy young gentlemen from Europe and Britain.*

From the early eighteenth century the aesthetic of chinoiserie became popular in European arts, which also influenced the production of fans. Chinoiserie, from the French word *chinois* (Chinese), refers to a style aligned with Rococo that features European interpretations of Chinese styles. Production of chinoiserie fans employed two main methods. In the first method, certain parts of

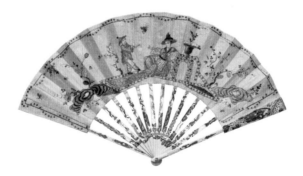

▲ Fig 5. Chinoiserie painted ivory folding fan, mid-18th century, 24 x 50 cm, Europe, Eurus Collection

the fan were produced by fan-makers in the East, while the others were completed by European fan-makers. The second method involved the European fan-makers appropriating and remodelling Chinese motifs. The popular

---

* The Grand Tour was a popular tour of Europe undertaken by upper-class young men from the mid-seventeenth to the early nineteenth century to gain exposure to European culture, from classical antiquity to the Renaissance. The duration of a tour ranged from three months to eight years.

chinoiserie folding fans were exhibited and sold by mer-chants who specialised in art objects (*marchands-merciers*) from the mid-eighteenth century, suggesting that fans were widely appreciated, not only by the upper classes but also by the emerging middle class.

During the eighteenth century lace fans were also popular and their designs followed fashion trends. The delicate and decorative lace produced in Brussels was highly valued and popular. During this period, fan artisans flourished and reached a sophisticated level of artistry. Artisans who painted on and decorated the leaves of fold-ing fans were considered artists. In addition to being a fashion accessory, fans were useful for communicating and playfully engaging with others. In 1797 Charles Francis Badini, a print designer, invented the "Fanology or the Ladies Conversation Fan", a printed fan inscribed with directions for how to communicate using fans.

## Nineteenth- to twentieth-century European fans

From the early nineteenth century production meth-ods for works of art and craft shifted from traditional, labour-intensive ways to easier and faster processes. The development of printing techniques and the invention of fan-stick manufacturing machinery drove significant increases in fan production. In the 1870s the invention of alternative materials such as celluloid made fans more affordable. Despite these developments, sophisticated and elaborate fans continued to be produced. Duvelleroy and Alexandre, fan-makers to the upper classes in nineteenth-century France, opened stores throughout Europe. In addition Duvelleroy compiled and published a leaflet designed to further draw popular attention to fans. The leaflet was named "The Language of the Fan" and

consisted of a series of illustrations demonstrating how to communicate with fans. The House of Fabergé, a jewellery house originating from St. Petersburg and best known for the decorative eggs it made for the Russian royal family, was also commissioned by the tsars to produce fans. Fabergé fans are known for their distinctive fan guards and use of enamel and jewels. Paintings on fan leaves by well-known painters such as Camille Pissarro, Paul Gauguin and Edgar Degas further elevated the fans' status. During this period the availability of a large variety of fans, from high-end ones made of expensive materials to affordable mass-printed ones, ensured that the high demand was met.

The Great Exhibition of the Works of Industry of All Nations, also known as the Great Exhibition or the Crystal Palace Exhibition, was held in 1851 in Hyde Park, London. The exhibition was considered to be the first world fair and exhibited cultural and industrial products from around the world, inspired by the British Industrial Revolution of the mid-eighteenth century. Fans were included in the Exhibition, and those made by both Duvelleroy and Alexandre received the Great Exhibition Prize Medals for their craftmanship.

From the mid-nineteenth century the influence of Japanese aesthetics known as Japonisme in France started to spread to the rest of Europe. Japan established diplomatic relations with Europe in the mid-nineteenth century and began to export ceramics, tea and fans. Moreover, Europe's interest in Japanese culture increased when works of Japanese art and craft were presented during the world fairs in London and Paris. Among them *ukiyo-e*, the multi-colour woodblock prints originally used for wrapping porcelain, were highly appreciated by the Europeans.

The simple yet bold composition of *ukiyo-e* works attracted the attention of French artists and was an important influence in European art. Such inspiration by Japanese aesthetics was present in fan-making as well.

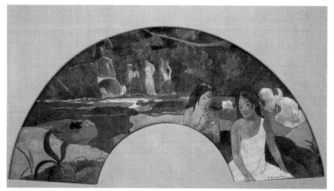

▲ Fig 6. Paul Gauguin, *Arearea (Joyfulness) II*, 1894, gouache and watercolour on linen, 28.6 × 58.4 cm, The Museum of Fine Arts, Houston

In the early twentieth century fan usage and demand decreased dramatically. However, the Art Nouveau and Art Deco style-inspired fans of that time went on to influence the fashion industry in the later part of the century. When designers such as John Galliano and Jean-Paul Gaultier used fans as motifs for their works, fans attracted attention once again. Today fan usage has expanded beyond their original role as fashion items. Fans today are used in advertising and as decorative ornaments, and remain relevant in the cultural domain. In addition, fans continue to be treated as critical collectible artefacts, with significant conservation efforts extended to maintain their well-deserved historical and artistic integrity.

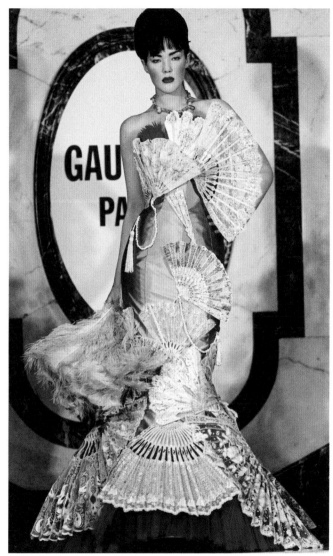

▲ Fig 7. Jean-Paul Gaultier, *Espagnolade Gown*, Divine Jacqueline Collection, Haute Couture Spring/ Summer, 1999

# 1. Elegant Life
Love and Pastoral Life of the Upper Classes

# Elegant Life

In seventeenth-century Europe Baroque art, which embodied an aesthetic of authority and grandeur based on absolutism, became popular. The word "Baroque" has its roots in the Portuguese phrase *pérola barroca* which means "irregular pearl". Baroque art established a dynamic and dramatic style in keeping with the spirit of Europe at that time. Baroque originated in Rome and later spread to Spain, France, Germany and Austria. The Palace of Versailles is representative of Baroque architecture and is characterised by a balance of symmetry, order and grandeur. This trend was succeeded by the Rococo style during the eighteenth century, which saw a movement to dismantle the absolutist order and ideology.

The eighteenth century is also called the Age of Enlightenment, a period whose spiritual paradigm was based on the twin axes of "reason" and "nature".* The doctrine of the Age of Enlightenment was to release the human spirit from subordination to the authority of the Church or the King, and to return it to its true nature. Therefore, on some level, the splendid Rococo style symbolising aristocratic culture could be perceived as contradictory to that doctrine. However, the aesthetics, diversity and autonomy that the Rococo style pursued had a lot in common with the ideals that were espoused by the Enlightenment movement. During the reign of Louis XV, under the patronage of his official chief mistress,

---

* The Enlightenment idea was established mainly in France in the 18th century and spread widely to neighbouring countries; it can be seen as an ideology preparing for a new era. The ideological foundation of the Enlightenment movement can be seen in the rationalism of the seventeenth century, the philosophical and political thoughts of John Locke's empiricism and in Isaac Newton's view of the universe. The Enlightenment thinkers believed in the infinite progress of mankind, based on the power of reason possessed by humans; they insisted on breaking through ignorance and superstition and boldly correcting and reforming the old system's opposition to reason. This Enlightenment idea became the ideological foundation of the American and French Revolutions and the driving force in the construction of a new civil society.

Madame de Pompadour, the Rococo style of art, crafts and architecture prevailed in France and rapidly spread throughout Europe.

The term Rococo originated from the French word *rocaille*, which refers to an elaborate decorative style using pebbles or shells, typically used for fountains and grottoes. Compared to the magnificent and authoritative Baroque style, the Rococo style is often exaggerated, with extravagant and sensual aesthetics. For the aristocracy and bourgeoisie, who enjoyed light play and entertainment, Rococo was a breakthrough that led to a new lifestyle, while maintaining a sense of discipline and elegance. Fans, as symbols of aristocratic culture, moved away from the dark and majestic tones of the previous era and were replaced with brighter and more vibrant colours. The beauty of atypical shapes and asymmetry found in the Rococo style was very personal, decorative and playful. During this period, fans became a necessity within the social culture and reached their apex in the cultural landscape. This expressive and decorative Rococo style seemed to come to an end after the French Revolution, but was reborn in the nineteenth century as "Rococo Revival".

**Rococo Revival style**

The French Revolution, which took place during the reign of Louis XVI at the end of the eighteenth century, laid the foundation for uprooting the tenets of the established system and replacing them with an ideology of liberalism and the growth of civil society throughout Europe. This transition to modernism brought about reforms in political and economic structures as well as changes in art and culture.

Neoclassicism, a popular style during the First French Empire under Napoleon, inspired patriotism with subjects from history, mythology and the classics. However, the Second French Empire, following the First and Bourbon Restorations, saw the emergence of "Rococo Revival", a style associated with aristocracy. At that time the patrons of culture were primarily aristocrats and representatives of an emerging powerful class, the bourgeoisie. Art and craft styles of the nineteenth century often demonstrate a mix of cultures from previous eras. The aesthetics of the Louis XV period, which represented the essence of the eighteenth-century Rococo style, were markedly evident in various art and craft works. The same phenomena were reflected in the evolution of the fan. Fans produced during the nineteenth century used the lives of the Bourbons and other aristocrats as subjects, with the bold use of scrolls featuring spirals and cartouches representing the Rococo architecture style. In addition, the subject matter chosen to decorate fan leaves reflected the Enlightenment ideals of finding love and leisure in nature.

Fans recorded significant events in the lives of European royalty, including weddings. Fans were often offered as gifts on such important occasions. This trend resulted in the emergence of art and craft works containing visual representations of the lives of nineteenth-century royalty. This phenomenon manifested the desire of Europeans to revive the monarchy and its traditions, which had been dismantled by the preceding political turmoil.

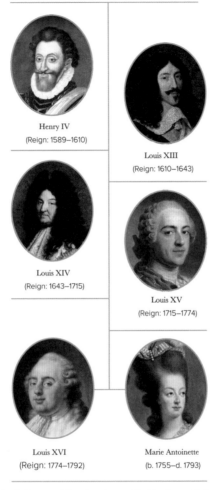

Henry IV
(Reign: 1589–1610)

Louis XIII
(Reign: 1610–1643)

Louis XIV
(Reign: 1643–1715)

Louis XV
(Reign: 1715–1774)

Louis XVI
(Reign: 1774–1792)

Marie Antoinette
(b. 1755–d. 1793)

▲ Fig 8. House of Bourbon,* compiled by Eurus Collection

* French decorative art from the 17th to the 19th century is categorised according to the name of the reigning king of each respective period. The following styles (presented in chronological order) are recognised: Henri IV (reign: 1589–1610), Louis XIII (reign: 1610–1643), Louis XIV (reign: 1643–1715), Louis XV (reign: 1715–1774) and Louis XVI (reign: 1774–1792). The subsequent styles are as follows: First French Empire style under Napoleon I (reign: 1804–1814), Louis Philippe I style (reign: 1830–1848) and the Second French Empire style under Napoleon III (reign: 1852–1870). The royal house of Bourbon usually refers to the royal family from the period of Henri IV to Louis XVI. The Revolution discontinued the royal genealogy. However, the early part of the nineteenth century saw the revival of this lineage (Bourbon Restoration period) along with the emergence of the Restoration style.

## "VERNIS-MARTIN" LACQUERED IVORY BRISÉ FAN
### France, early 18th century

Painted with a pastoral "Moment musicale" front and a landscape back, guards with incidental chinoiserie decoration, signed "L. Bayard", 19 × 34.5 cm

This fan is made of ivory and painted with gouache. Its pastoral landscape artwork is quite striking. The fan is made solely of decorative sticks without a leaf, with the top part connected by a ribbon and the bottom part fixed with a pivot pin. This fan is finished with a "Vernis Martin" (Martin varnish) technique, which is similar to the lacquer technique popular in East Asia. In the seventeenth century craft works made using the East Asian lacquer technique became available in Europe and were much admired by Europeans due to their rarity. The Martin family in France developed their own variation of the technique ("Vernis Martin", after their family name) in the eighteenth century. It was one of many techniques imitating East Asian lacquer during that period.

The front of the fan illustrates a romantic scene of a man playing the flute and a woman listening to the music. Both are seated under a tree and are enjoying the idyllic surroundings. A beautiful landscape is depicted on the back. The fan's guards and sticks are decorated with Chinese motifs. The name "L. Bayard" is inscribed on the right side of the fan's front.

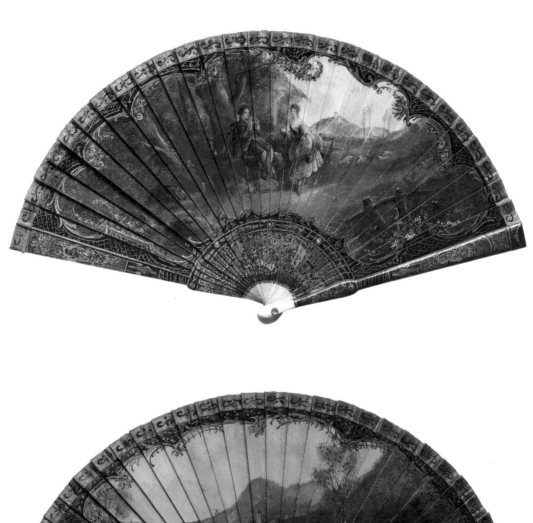

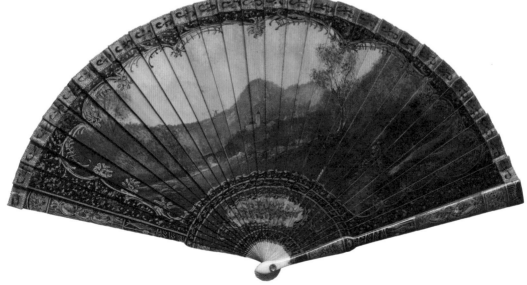

**LOUIS XV-STYLE PAINTED VELLUM AND IVORY FAN**
France, mid-18th century

Central cartouche painted with a "Moment pastorelle" framed by Rococo tracery, pierced monture picked out in pastel and metallic tones, 24.5 × 44.5 cm

The monture (sticks and guards) of this fan are made of ivory and the leaf is painted in gouache on vellum. At the centre of the fan's front is a painting of a pastoral scene with a man and two women fishing. The scene is depicted within the frame of a vine pattern, which is a typical characteristic of Rococo during the Louis XV era. This type of cartouche* frame using spiralling scrolls was also commonly used in Rococo furniture and architecture. The fan sticks are fashioned into individual circular shapes which are connected together. The resemblance of these shapes to a tennis racquet led to this type of fan becoming known as a "battoir" fan. The motifs of engraved circular shapes in battoir fans are often inspired by nature and include flowers and plants.

* Cartouche is a decorative element found in Rococo architecture and interior decoration. It was also used in paintings and crafts as a kind of frame decoration, as well as in book and letter illustrations.

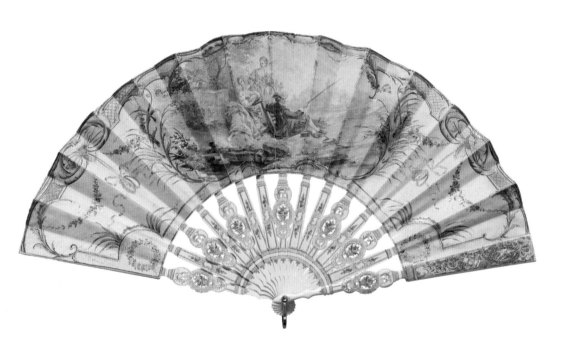

## LOUIS XV-STYLE PAINTED PAPER AND IVORY FAN
### France, c. 1870

Painted with a central "Conversation galante" and two subsidiary reserves from the narrow leaf onto the deep gorge, without interruption and framed by Rococo scrolls; pierced monture picked out in gold, the outer edge embellished with spangles, 21 × 39.5 cm

This fan has relatively wide sticks and its ivory monture is pierced and picked out in gold. The leaf is attached to the top part of the monture and is made of paper, with a spangle decoration wrapped around the leaf edges. The painting is spread out seamlessly over the fan sticks and leaf, and its subject matter is elegantly divided across three scenes by spiraling scrolls. The centre of the fan contains a painting of a "Conversation galante" depicting a romantic scene between a man and a woman in colourful attire, typical of the Rococo in style. The man in the picture is wearing a pigtail wig, which was popular during the Louis XV period. The woman is wearing a robe *à la polonaise*, an eighteenth-century garment which is rolled up on both sides, and a ribbon-pleated overdress with a visible underskirt. The woman is seen wearing a choker around her neck.

The fan's production date is estimated to be during the Second French Empire (1852–1870), when the Rococo Revival style was in full swing. The Rococo Revival style aimed to revive the traditions and legitimacy of the Rococo style from the Louis XV period.

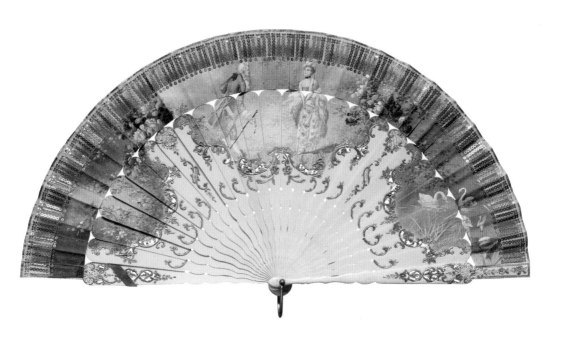

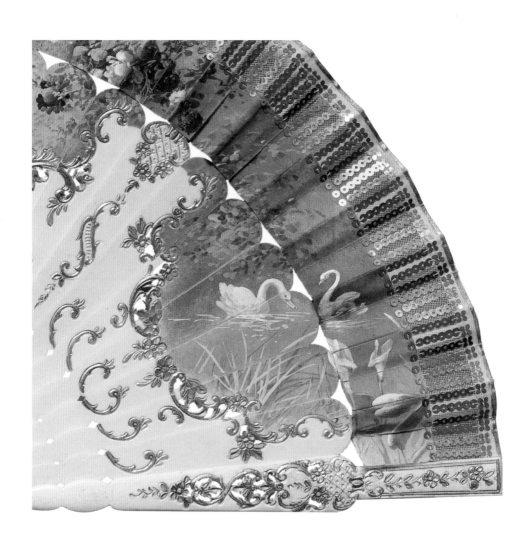

1-3. Louis XV-style painted paper and ivory fan (detail), France, c. 1870

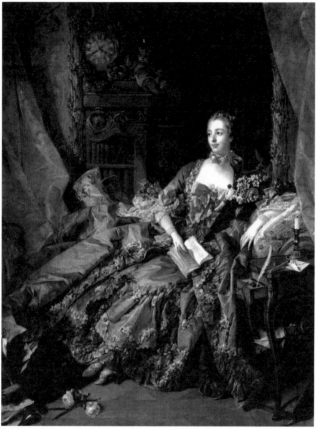

▲ Fig 9. François Boucher, *Madame de Pompadour*,* 1756, oil on canvas, 212 × 164 cm, Alte Pinakothek, Munich

---

* Madame de Pompadour was the official chief mistress of Louis XV. With her beauty and intellect, she was very much loved by the king. Madame de Pompadour worked with Enlightenment thinkers to promote learning and had a significant influence on the development of the Rococo style through her patronage.

## LOUIS XVI-STYLE PAINTED VELLUM AND MOTHER-OF-PEARL FAN
### France, late 18th century

Decorated with figural reserves and musical trophies, pierced monture picked out in gold and silver, signed "P. Chaloy", 22 × 39.5 cm

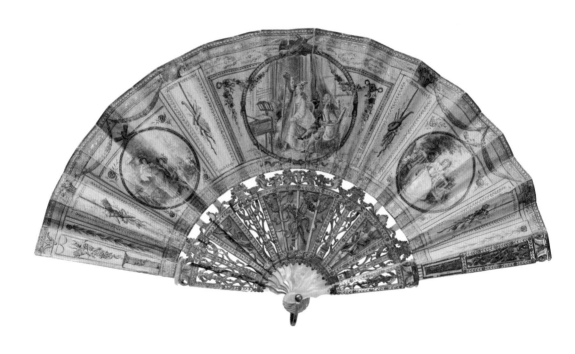

This fan appears to be a mixture of the Rococo and Neo-classical styles, the latter inspired by ancient Greek and Roman cultures. The discoveries made during the excavation of ancient archaeological sites in the early eighteenth century renewed Europeans' interest in ancient Rome and Greece. These themes from antiquity influenced the production of art and craft works. The pierced monture is elaborately picked out in gold and silver. The fan leaf is painted with gouache on vellum and contains three circular medallions, each with a different painting. Between the medallions, there are paintings of colonnades and walls decorated with love allegories in the form of wreaths, ribbons, musical instruments and trophies.

The central circular medallion on the fan leaf contains three figures – an upper-class woman playing the harp surrounded by two male admirers. The woman is wearing a high headdress in "fontange" style, decorated with feathers, and an eighteenth-century styled dress. The man on the left is conversing with the woman. The man on the right listens to the music while posing with one hand on a dress cane and the other holding a hat on his lap. In front of the harp, there is a harpsichord, the predecessor of the piano.

The medallions represent love as the main theme against the background of a pastoral scene, with the left side medallion portraying two lovers and the right side medallion showing an image of an elegant woman awaiting her lover. Below the fan leaf, the middle part of the gorge is decorated with bows in a quiver, another love symbol. The patterns of ribbon knots, torches and Greek pillars are elaborately carved around the gorge. The middle of the fan leaf is signed "P. Chaloy".

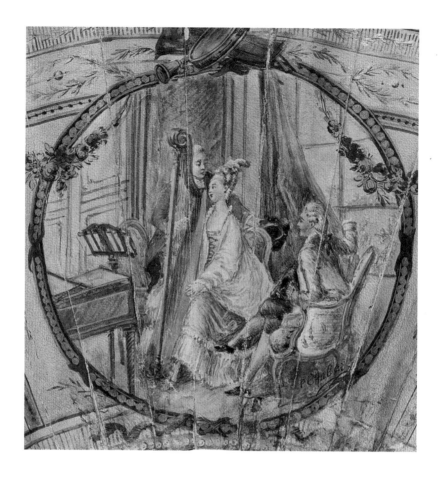

1-4. Louis XVI-style painted vellum and mother-of-pearl fan (detail),* France,
late 18th century

---

* The artwork in the centre medallion resembles the copper etching work *L'accord parfait*, part of an
illustrated book depicting an upper-class female character, Céphise. Céphise is portrayed playing
the harp, a popular instrument among the aristocratic ladies of that period and one of the instruments
favoured by Marie Antoinette, the wife of Louis XVI. *L'accord parfait* was a much-admired artwork and
has been appropriated in craft works such as fans and Sèvres porcelain vases.

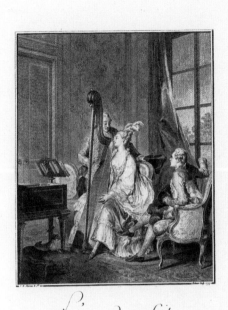

▲ Fig 10. Isidore-Stanislas Helman, *L'accord parfait*,* 1777, etching, 39.9 × 31.3 cm, Rijksmuseum, Amsterdam

---

* *L'accord parfait* is a copper etching by Isidore-Stanislas Helman in 1777, based on the artwork by Jean-Michel Moreau. It was a part of an etching collection, "Monument du Costume Physique et Moral de la Fin du Dix-huitième Siècle ou Tableaux de la Vie", published in 1789. The collection consisted of 26 etchings accompanied by texts written by Rétif de la Bretonne illustrating the life of the aristocracy and was very popular at that time.

## HAND-COLOURED LITHOGRAPHED PAPER AND IVORY FAN
### Probably France, late 19th century

Decorated with several figural
vignettes front and back, pierced
and piqué monture, signed
"J. Berthier", 27.2 x 49.3 cm

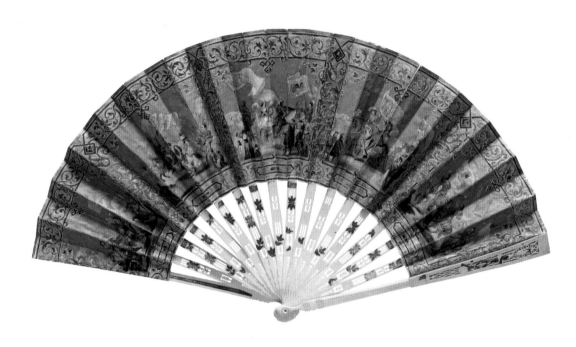

This special fan, whose sticks and guards are made of ivory, depicts a royal procession. The fan leaf is printed in lithograph* and coloured with gouache. The front of the fan is dominated by gold, and the complex procession is neatly divided into five scenes, with vines and swirls wrapped around the edges of each scene, thus acting as a border.

In the middle of the procession there is a depiction of a king and a queen, surrounded by figures who appear to be guards, dressed in medieval clothing. The spectators watching the colourful procession imbue the painting with a sense of gaiety. The fan sticks are elaborately inscribed with a plant pattern, believed to be lilies, symbolising the French royal family and adding a touch of delicacy to the fan.

On the back of the fan, there are three frames depicting a scene with people from different classes gathered together, enjoying the countryside. Compared to the gouache-coloured front side, the back is print-only and relatively abrasive. The lithograph technology of the period was capable of printing patterns onto a fan leaf. This technology reduced the cost of producing fans by substituting expensive vellum with paper. The back carries the signature "J. Berthier".

---

* Lithography is a printing process invented by a German playwright, Alois Senefelder, at the end of the 18th century. The process uses a reaction between water and oil and was used in art and craft works throughout the 19th century.

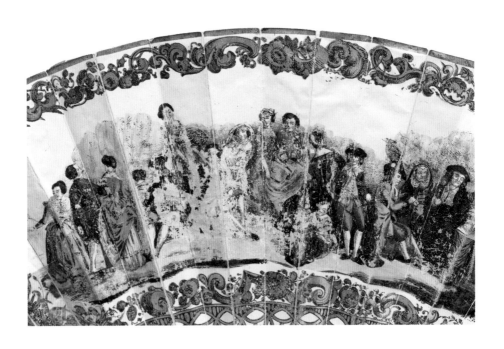

1-5. Hand-coloured lithographed paper and ivory fan (detail reverse), probably France, late 19th century

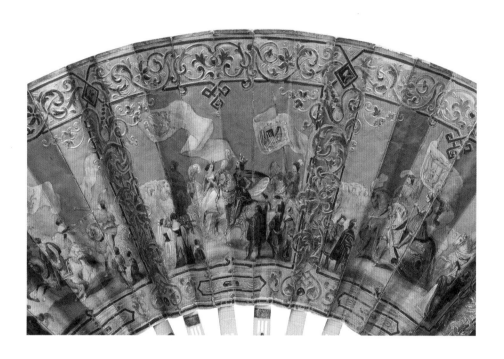

1-5. Hand-coloured lithographed paper and ivory fan (detail), probably France, late 19th century

I-6

HAND-COLOURED
LITHOGRAPHED PAPER AND
EBONISED WOOD FAN
Europe, mid-19th century

Medieval "Fête galante"
reserved from an ornate ground,
polychrome monture, 27.2 x 51 cm

This fan's leaf is lithographed and then painted. The centre of the fan leaf depicts a boating scene with women and men in medieval clothes. Multiple circular wreaths with birds at their centres decorate the left and right sides of the leaf. The base of the fan sticks is made of ebonised wood, a technique to darken the wood with stains or paint. The middle part of the gorge contains a pair of flowers in bloom surrounded by symmetrical organic curves. The fan head, the lowest part of a fan that holds the fan sticks together, is partially decorated with ivory.

The painting on the fan leaf is categorised as "Fête galante", a genre of painting featuring scenes of the aristocracy in fashionable clothes enjoying festive amusements – flirtatious games, banquets, boating and musical performances – against the backdrop of an idealised outdoor landscape. The boating scene depicted on this fan is typical of the "Fête galante" genre and symbolises ideal love, with water representing life, love and everlasting youth.

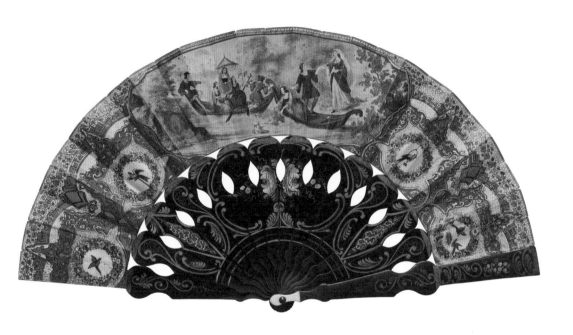

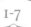

## I-7

### HAND-COLOURED LITHOGRAPHED PAPER AND PAPIER-MÂCHÉ FAN
### Europe, mid-19th century

Leaf printed with a "Fête galante", the sticks decorated in polychrome and gilt depicting a classical scene, 27 x 52 cm

The fan sticks and guards, made of papier-mâché,* depict a boating scene in splendid colours. The fan leaf, painted with gouache over lithographed paper, illustrates youthful figures in elegant attire enjoying their leisure in a pastoral setting.

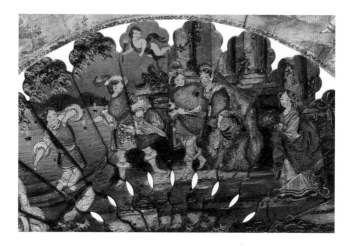

---

* Papier-mâché is believed to have originated in China. France used papier-mâché products in the 18th century before it spread to the rest of Europe.

**I-8**

PAINTED VELLUM AND
MOTHER-OF-PEARL FAN
France, mid-18th century

Painted with a "Moment musicale",
pierce-carved monture picked out
in gold and silver, 28 x 52 cm

The sticks and guards of this fan are pierce-carved and picked out in gold and silver. The fan leaf is made of vellum and painted with gouache. It is a peaceful countryside setting with a man playing the guitar and a woman holding a sheet of music, while spectators enjoy the performance. The right side of the fan leaf portrays a man holding a floral wreath and a woman holding a flower basket. The floral wreath, flower basket and musical instruments are traditional symbols of love.

Looking at the fan sticks closely, one can observe that the mother-of-pearl is delicately sculpted and elaborately layered, with three scenes of a man and a woman engaged in conversation. The human figures and the decorative curves are made of gold and silver, while the natural mother-of-pearl is used for the background.

Fans produced in the second half of the eighteenth century were larger than their predecessors and reached a semi-circle in their fully unfolded state. To enable mass production, the fans' surface was lithographed and then coloured. Fans produced in this manner became affordable to many people. However, upper-class women preferred to own fans that were ornately decorated with precious materials.

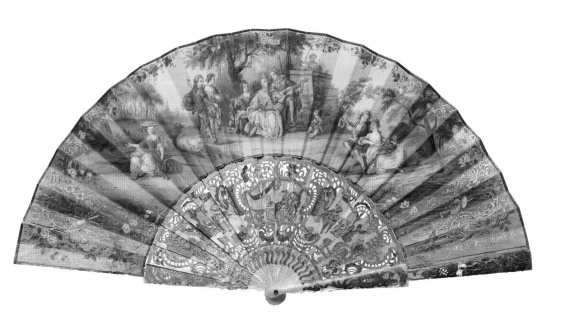

### HAND-COLOURED LITHOGRAPHED PAPER AND CAMEO-CARVED MOTHER-OF-PEARL FAN
### Europe, mid-19th century

The narrow leaf decorated with figural vignettes, the monture carved in cameo style with various figures and fruiting vinery, 27 x 53 cm

This fan's sticks, made of mother-of-pearl, are elaborately sculpted with a group of figures and the leaf is painted with gouache over a lithographic print. The centre of the fan leaf depicts a man playing a guitar, a woman holding a sheet of music, a child and two sheep, against a pastoral background. The right side of the fan leaf depicts a man holding a floral wreath and a woman with a flower basket, symbolising that their love will soon be consummated. This fan is distinctive for its relatively narrow leaf and its wide gorge made of mother-of-pearl. The gorge is carved with rich grape vines and a group of figures in cameo style, making the figures appear more realistic. The fan's beauty is enhanced by the contrast of light and reflection, creating a layer inside the mother-of-pearl.

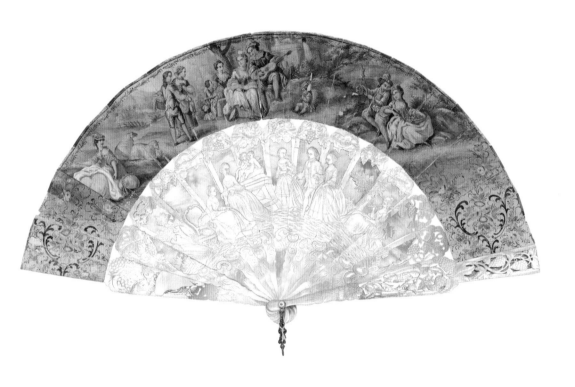

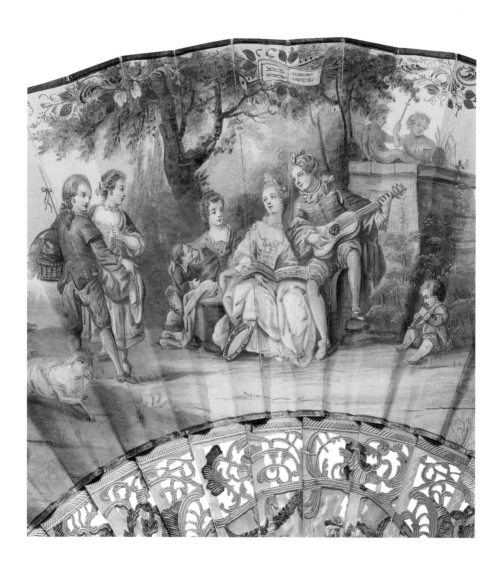

1-8. Painted vellum and mother-of-pearl fan (detail),* France, mid-18th century

---

* Scenes of men and women enjoying their leisure while playing musical instruments in idyllic settings were a popular theme for fan leaves during the 18th and 19th centuries. As similar scenes can be found on other fan leaves, it is assumed that a printing plate with a fixed composition was used to create them.

1-9. Hand-coloured lithographed paper and cameo-carved mother-of-pearl fan (detail), Europe, mid-19th century

I-10

PAINTED VELLUM
AND IVORY FAN
Europe, mid-18th century

Pastoral vignettes front
and landscape back, piqué
monture, 27 x 47 cm

The sticks and guards of this fan are made of ivory. The fan's vellum leaf depicts an interesting story unfolding in the countryside. Fan design changed after the 1760s whereby the scene on a fan leaf was often divided into one large scene and two smaller ones.

The fan leaf harmoniously mixes three different stories set in an idyllic setting. The central scene depicts a man and a woman engaged in a romantic conversation. The left side of the fan shows a man carrying a flower basket on his head. The right side shows a woman looking into a mirror, which symbolises vanity. The overall theme of the three scenes is that love is fleeting, albeit exciting and enjoyable at times.

The figures on the fan leaf are depicted with round and pink faces and small bodies. The fan sticks are narrow and spaced at regular intervals, and there is a simple decoration at the top. This is a style that has often appeared in European fans in the second half of the eighteenth century.

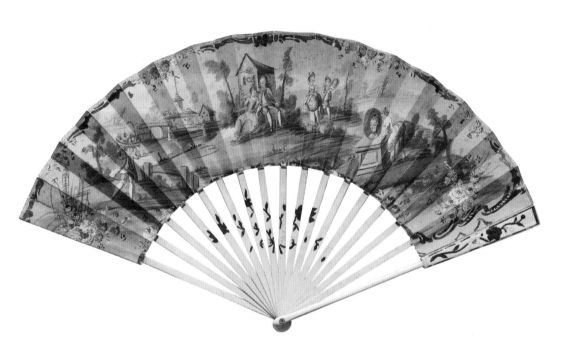

PAINTED VELLUM AND
MOTHER-OF-PEARL
CABRIOLET FAN
Europe, 19th century

"Conversation galante" *à la dix-huitième* and subsidiary landscape reserves framed by Rococo scrollwork, 21.5 x 39.5 cm

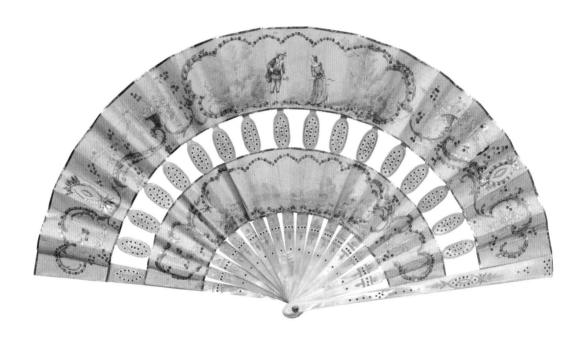

This fan, whose sticks are made of mother-of-pearl and decorated with inlay techniques, consists of two concentric fan leaves made of vellum and painted with gouache. The fan is decorated with swirling patterns, indicating the influence of the Rococo style. The middle of the fan leaf's upper section depicts a woman and a man engaged in a romantic conversation and the lower section displays a pastoral landscape.

Such uniquely designed fans, with their concentric leaves, are known as "cabriolet" fans. A cabriolet was a light horse-drawn carriage produced in Paris from the mid-1750s, remarkable for its large wheels and the unique shape of its hood. The slender fan sticks used in cabriolet fans resemble the spokes of cabriolet wheels. Cabriolets also influenced the design of costumes and crafts. The most common subjects depicted on this type of fan were ladies in horse-drawn carriages. However, this particular example depicts a romantic scene in a pastoral setting.

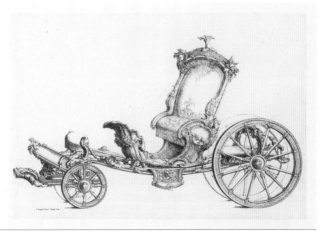

▲ Fig 11. Johann Michael Hoppenhaupt II, *Design for a Cabriolet*, 1753, etching on cream laid paper, 44 x 30.6 cm, Cooper Hewitt, Smithsonian Design Museum, New York

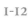

I-I2

HAND-COLOURED
LITHOGRAPHED VELLUM AND
IVORY COMMEMORATIVE FAN
Probably France, c.1846

Pierced and piqué monture, the
guard with peeping mirror and
cameo, 27.5 x 53 cm; black cardboard
box stamped Duvelleroy, Paris

This fan was specially made to commemorate the wedding of Isabella II (1830–1904) of Spain in 1846. The fan sticks, made of ivory, are pierced and decorated with gold. One of the guards is equipped with a peeping mirror so that the fan owner can see herself or spy on others. The other guard is decorated with a cameo. The vellum fan leaf is painted with gouache, the event being the queen's wedding to her cousin Francisco de Asís, Duke of Cádiz. On the reverse side there are portraits of the bride and the groom, the mother of the bride, Queen Consort Maria Christina, and the uncle of the bride, Infante Carlos.

After the seventeenth century fans became an important fashion accessory for European royalty and the upper classes. Royal families commissioned specially designed fans for important events, including weddings, to record these historic moments for posterity. These commemorative fans were offered as gifts to the ladies attending those events. This fan comes with a black fan case, inside which the seal "Duvelleroy Paris Pass. Des Panoramas" is printed.

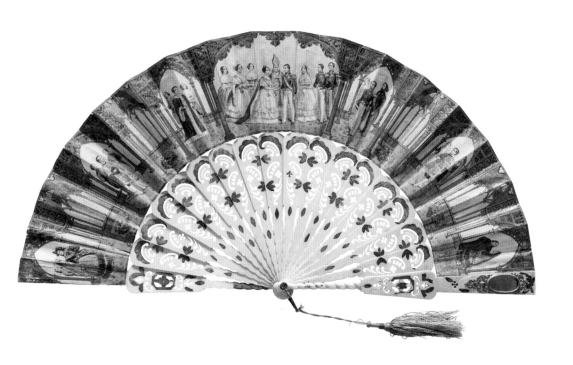

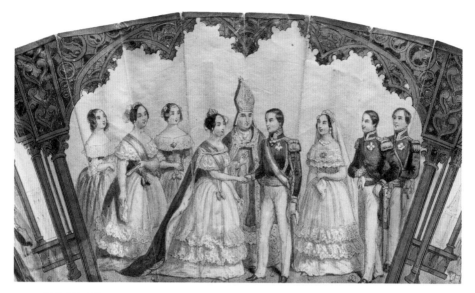

1-12. Wedding scene of Isabella II and Francisco de Asís, Duke of Cádiz (detail)

1-12. Portraits of Isabella II and Francisco de Asís, Duke of Cádiz (detail reverse)

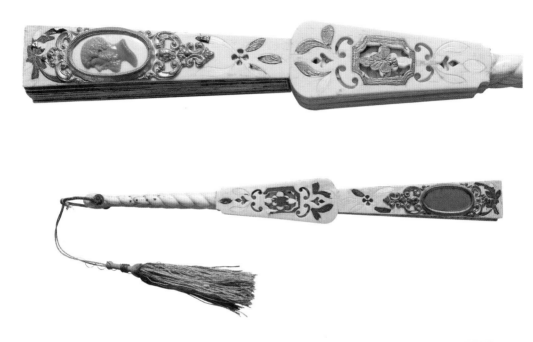

1-12. Guard with a cameo, guard with a peeping mirror and fan case* (top to bottom)

* Duvelleroy, a Parisian fan-making house, was founded in 1827 by Jean-Pierre Duvelleroy and produced luxurious fans for the royal families. Duvelleroy's atelier was situated on Passage des Panoramas, the first shopping arcade in Paris.

HAND-COLOURED
LITHOGRAPHED PAPER AND
MOTHER-OF-PEARL FAN
Europe, mid-19th century

Printed with romantic and
historicised vignettes, the
piqué monture with gold and
stylised motifs, 26.5 x 51 cm

This fan stands out from others due to its predominately blue-toned leaf. Its monture, made of mother-of-pearl, is elaborately decorated with floral motifs in gold piqué.

The fan leaf displays a panoramic scene made up of five individual sections, each depicting a romantic scene between lovers dressed in seventeenth-century costume. The men are wearing culottes and the women are wearing boat-neck dresses which reveal the silhouette of their necks and shoulders. The centre of the fan leaf depicts a pleasant engagement scene in a garden, with a statue of Cupid in the background. A man and a woman are shown listening to another woman playing a stringed instrument. The enduring theme of romance permeates the scenes, with symbols such as the stringed instrument and the statue of Cupid. Upon close inspection, the second scene from the left shows a servant of apparently African descent, offering a glimpse into the colonial life in Europe at that time.

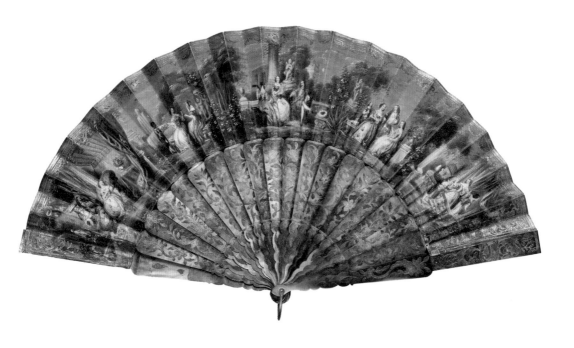

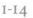

### I-14

**LOUIS XIII-STYLE PAPIER-MÂCHÉ FIXED FAN**
Europe, mid-19th century

Polychrome lacquered
papier-mâché, painted with a
figural vignette *à la Louis XIII*,
ivory-decorated and ebonised
wood handle, 38 x 25 cm

This hand-screen fan, a type of fixed fan, appeared in Europe in the nineteenth century. It served to shield a person's face from the sun or from the heat of an open fire. Compared to a folding fan, a fixed fan has a rigid fan screen with a handle attached to it. The screen is usually made of hard materials formed into various shapes.

The screen of this particular fan is made of lacquered papier-mâché and the handle is made of ivory and ebonised wood. The scene is a hunting lodge in which a man is depicted holding a falcon on his left arm. There are several other falcons and a trainer, on the right side of the screen, waiting for the hunt to begin. Falconry was introduced to Europe from Central Asia. Louis XIII was known to enjoy this activity and during his reign falconry's popularity reached its peak.

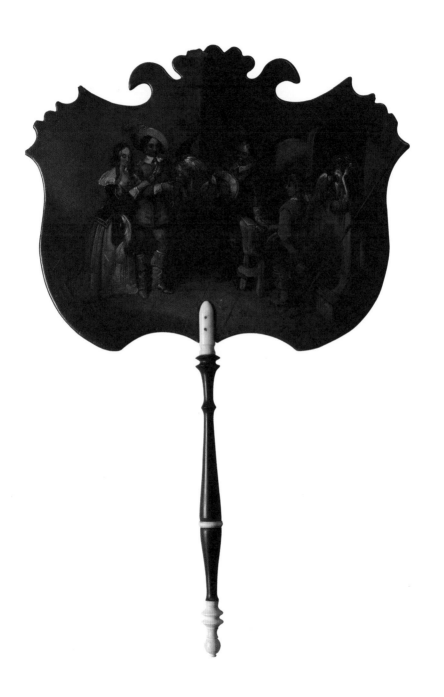

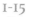

**I-I5**

## LOUIS XIII-STYLE PAINTED FABRIC AND IVORY FAN
Europe, late 19th century

Painted with a coaching vignette
*à la Louis XIII*, the monture carved
in Rococo style and picked out
in polychrome, gold and silver,
signed "J. Meseguer", 23 x 41 cm

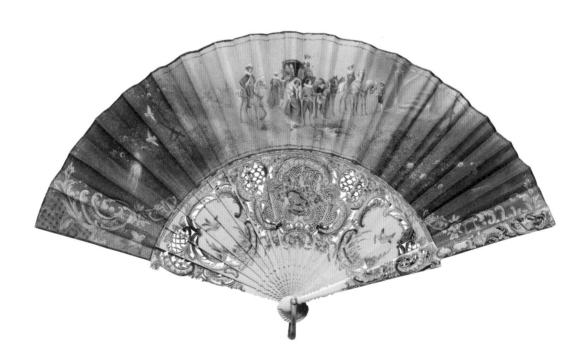

This fan, a mixture of Baroque and Rococo styles, is striking due to its elaborately carved sticks and guards. The monture, made of ivory, is engraved with Rococo-style geometric patterns and plant shapes. It is also colourfully decorated with gold and silver inlays. By contrast, the fan leaf is decorated using a technique which highlights the subject by utilising light against a dark background, as seen in Baroque paintings. European fans produced in the late nineteenth century are characterised by a mixture of styles from earlier periods.

At the centre of the fan leaf is a set of figures dressed in Louis XIII-style costume arriving at a banquet in a carriage. They are wearing pleated collars – ruffs – around their necks. Ruffs were popular in Europe during the sixteenth and seventeenth century, and their size changed depending on fashion trends. On the right side of the fan leaf is an entrance staircase leading to the scene of the event, suggesting various stories waiting to unfold.

The gorge is decorated in three parts, with a floral wreath in the centre and a bird on each side. The bird on the right side carrying a branch symbolises that love will soon show its face. Each part has its unique appearance, with the carved openwork at the centre accentuating the sophistication of the fan. An inscription, "J. Meseguer", appears at the bottom right of the fan leaf.

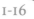

I-16

## LOUIS XIV-STYLE HAND-COLOURED LITHOGRAPHED PAPER AND IVORY FAN
### Europe, late 19th century

Printed metallic motifs, centre depiction of Louis XIV and courtiers in the park of Versailles, 27 x 50 cm

This fan's entire leaf is printed with repeating golden geometric patterns. The artwork in the centre is an elaborate depiction of Louis XIV and his courtiers at the park of Versailles. Louis XIV, known as the Sun King, was a powerful monarch whose authority was centred around the Palace of Versailles. He was known to be well-versed in the arts including ballet, music and architecture. Louis XIV was also known for his red shoes, including a high-heeled pair in that colour, or for having the colour red featuring in the tongue or in other parts of the shoe. On the fan leaf Louis XIV is portrayed in a pair of shoes with what appears to be a red ribbon or tongue. Looking at the artwork on the fan leaf closely, one can see women holding fans. This illustrates that fans were already an essential fashion item during the seventeenth-century Baroque period.

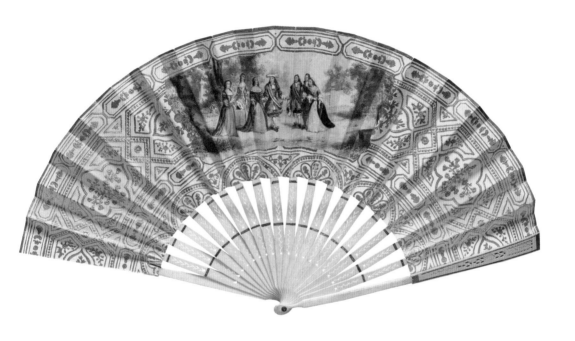

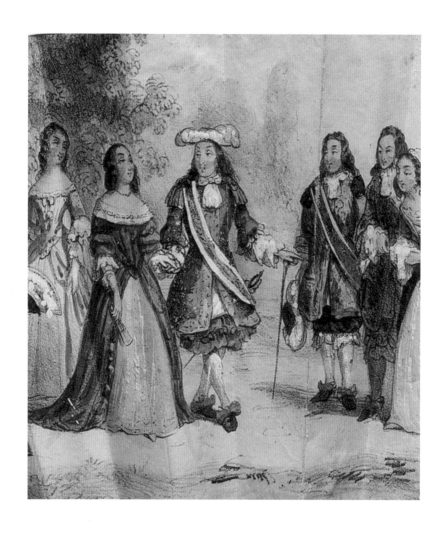

1-16. Louis XIV-style hand-coloured lithographed paper and ivory fan (detail),
Europe, late 19th century

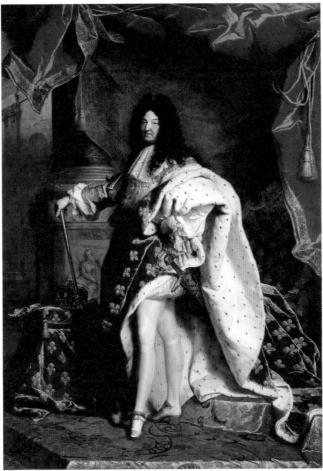

▲ Fig 12. Hyacinthe Rigaud, *Portrait of Louis XIV*,* 1701, oil on canvas, 277 × 194 cm, Louvre Museum, Paris

---

* Louis XIV, the Sun King. In the Age of Discovery, from the 15th to the 18th century, Europe's power expanded and its political landscape changed significantly. The question of who controlled the State was an important issue of the time. The idea of absolute monarchy, or the Divine Right of Kings, was used to justify royal authority. This portrait of Louis XIV personifies the dignity of a powerful king who embodied this idea. The painting was created in 1701, the 58th year of Louis XIV's enthronement, when he was 63 years old. The king is seen wearing shoes with red heels and coronation robes stylised with lilies, a symbol of the French monarchy. The red canopy and the large marble pillar symbolise the king's power and glory.

I-17

PAINTED FAUX
IVORY BRISÉ FAN
Europe, late 19th century

Convex scallop shell form,
decorated with an 18th-century-
style "Fête galante", 14 x 24 cm

The shape of this brisé fan resembles that of a scallop shell. The fan sticks are made of imitation ivory. The painting on the fan, depicting a group of figures enjoying themselves at an aristocratic party with music, reflects a scene from upper-class life. The figures are dressed in eighteenth-century Rococo attire and are shown dancing, conversing or simply sitting and observing the party. The mix of Rococo-style chairs and decoration, Chinese-style screens and ceramics and the classical architecture outside the hall represent an idealised setting for the party. The fan is remarkable due to its unique shape and its sophisticated painting style.

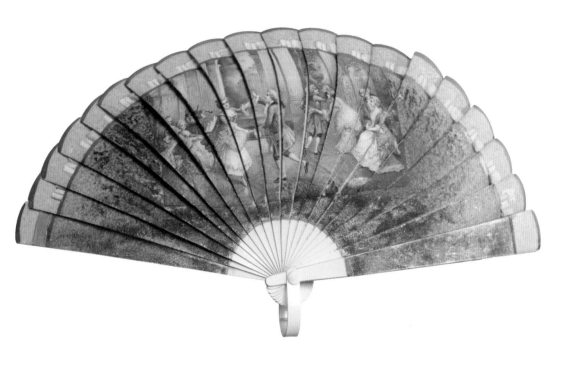

**PAINTED BLACK SILK GAUZE
AND TORTOISESHELL FAN**
England, late 19th century

Front painted in colour on black silk
gauze showing an 18th-century-style
"Conversation galante" framed with
black lace, tortoiseshell monture,
signed "F. Houghton" lower right
of pictorial reserve, 39 x 74 cm

This fan leaf was painted by Francis Houghton, whose signature appears in the lower right corner of the artwork. Francis Houghton was an English fan painter of the late nineteenth century. He is known for painting dramatic scenes on fan leaves. The fan sticks and guards are made of tortoiseshell. The artwork, which is framed with black lace, is painted on black silk gauze, a fabric similar to chiffon but lighter in weight. In the centre of the fan leaf, a tableau of three figures in a parlour in eighteenth-century attire is dramatically spotlighted: a woman is playing chess with one man while engaging in a romantic conversation with another. Two fans are shown in the painting – a folding fan to provide privacy for the discreet conversation and an Eastern-style fixed fan, positioned on a stool by the fireplace. In the background there is a large painting of a woman and a clock can be seen above the fireplace. In addition, there is a fire screen decorated with a painting, an indoor plant, an animal skin on the floor and a Chinese-style screen. These objects demonstrate the luxurious lifestyle of the aristocracy of the time.

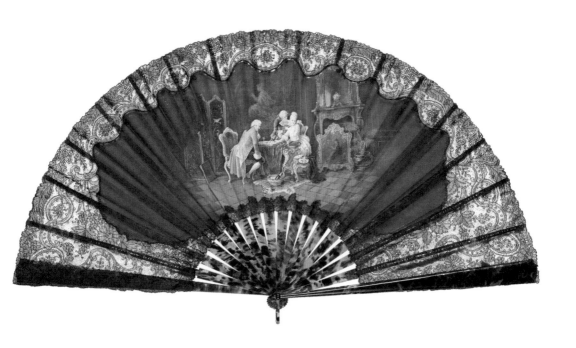

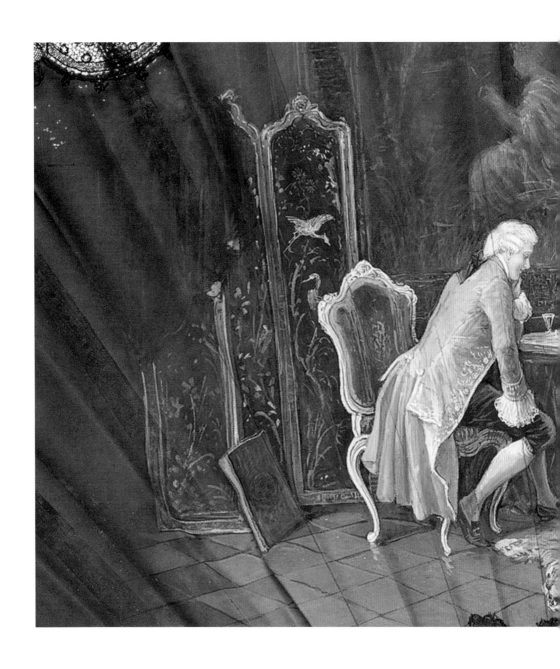

1-18. Painted black silk gauze and tortoiseshell fan (detail),* England, late 19th century

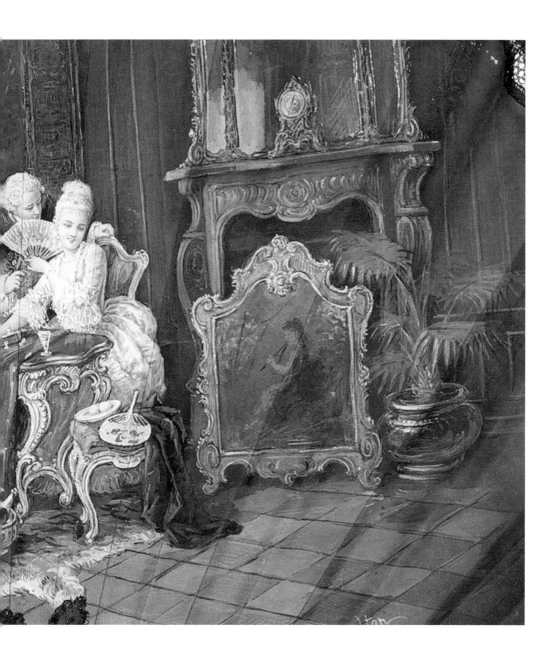

* As seen on the fan leaf artwork, the fan, as a portable accessory, was useful for communicating with others as an extension of body language. In addition to Charles Francis Badini's "Fanology" of 1797, in the early 19th century Duvelleroy published a leaflet, "The Language of the Fan". See Appendix for fan gestures and their corresponding meaning.

I-19

PAINTED VELLUM AND
MOTHER-OF-PEARL FAN
Europe, late 19th century

Painted with a "Conversation
galante" *à la dix-huitième* flanked
by sprays of flowers and
flying insects, 24.5 x 46 cm

This fan's sticks and guards are made of mother-of-pearl and the vellum fan leaf is painted with gouache. The centre of the fan leaf depicts three figures in a garden, with remnants of buildings in the background. The man in red attire is leaning against a railing while holding a small book and conversing with two women. The flowers, butterflies and dragonflies beautifully frame the main scene. With its overall colour scheme of bright pink, chartreuse and yellow, together with the eighteenth-century-style theme of a "Conversation galante", the fan is a splendid piece of craft work.

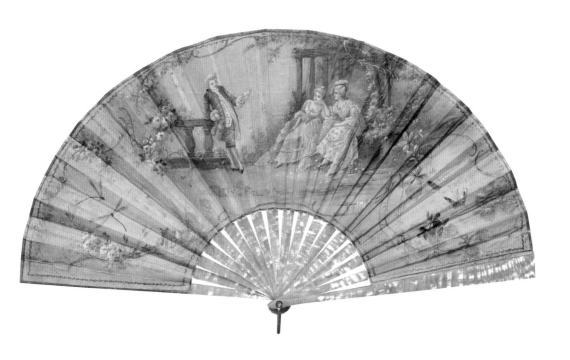

HAND-COLOURED
LITHOGRAPHED PAPER AND
MOTHER-OF-PEARL FAN
Probably France, 19th century

Romanticised "Moment
pastorelle" central reserve, the
guards with Sèvres-type porcelain
applications, label of J. Duvelleroy,
London, 14.5 x 45.5 cm

The fan leaf depicts a medieval-style pastoral landscape. In the centre are two women situated by a river, one seated on a stone chair with a red feather fan in her hand, the other dressed in red attire and standing by her side. Two men are on board a boat, one of them rowing and the other playing a guitar. The scene implicitly suggests the possibility that the women pictured will join the men for a boat ride. On the reverse of the fan leaf is a luscious forest where a romantic engagement between two lovers is taking place while Cupid watches over them. The man, dressed as a Roman soldier, has laid his helmet on the ground and is being presented with a floral wreath by the woman. The wreath signifies love and the union between the couple. The notable part of this fan is the guards, which are made of fine porcelain in the French Sèvres style. The fan case, which is covered in white silk, is engraved "J. Duvelleroy, London" in gold. Since Duvelleroy had a branch office in London, it seems probable that the fan was made in France and sold in London.

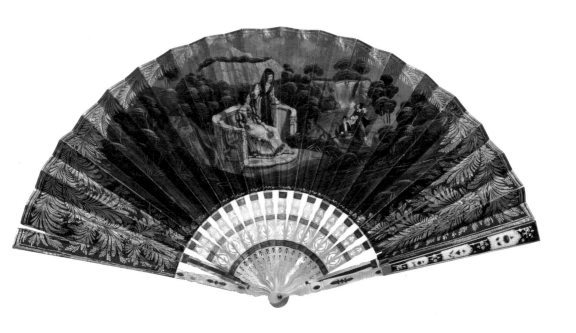

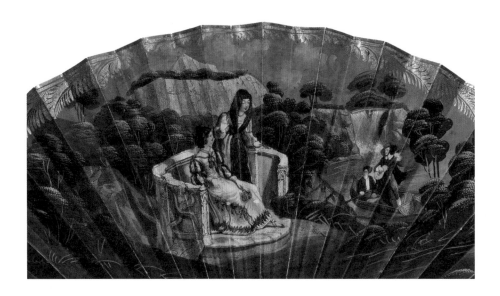

1-20. Hand-coloured lithographed paper and mother-of-pearl fan (detail), probably France, 19th century

1-20. Hand-coloured lithographed paper and mother-of-pearl fan (detail reverse), probably France, 19th century

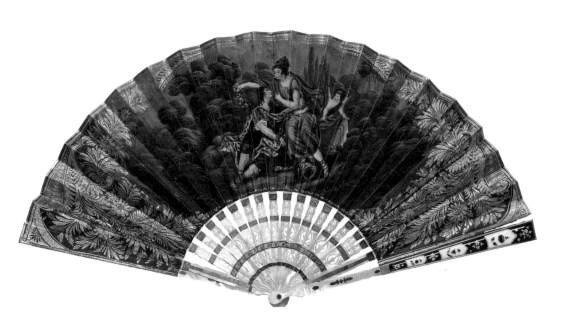

1-20. Hand-coloured lithographed paper and mother-of-pearl fan (detail reverse), probably France, 19th century

I-2I

▲ PAINTED ORGANZA AND
FAUX IVORY FAN
Europe, early 20th century

With a vignette of two couples in a playful
flirtation, pierced monture, 26 x 49 cm

I-22

▼ PAINTED FABRIC AND
CELLULOID FAN
Europe, 19th century

Painted with a "Moment
pastorelle", 28 x 52.5 cm

▲ This fan's sticks are made of imitation ivory and its organza* leaf is coloured with gouache. The fan leaf depicts two couples in eighteenth-century dress, playfully flirting on a seesaw. Looking closely at the artwork, the woman dressed in blue is barely holding on to the seesaw while a man dressed in red is supporting her from below. At the other end of the seesaw another woman, having lost her hat, is leaning against a man. This appears to be a typical eighteenth-century depiction of romance and flirtation between lovers.

▼ This fan's sticks are made of celluloid** and the fan leaf is painted with gouache on fabric. Depicted on the leaf is a couple engaging playfully with one another, the man pushing the swing on which the woman is seated. The swing is used as a means to play out flirtatious games, as seen in Jean-Honoré Fragonard's painting *The Happy Accidents of the Swing*. The woman to the side with her hand in the air is observing the scene.

---

* Organza is a kind of fabric made from silk. It is sheer yet stiff.
** Celluloid is a type of plastic and is made of nitrocellulose. It was invented by John Wesley Hyatt in the USA in 1869. It is widely used for fan sticks because it is inexpensive and easy to process.

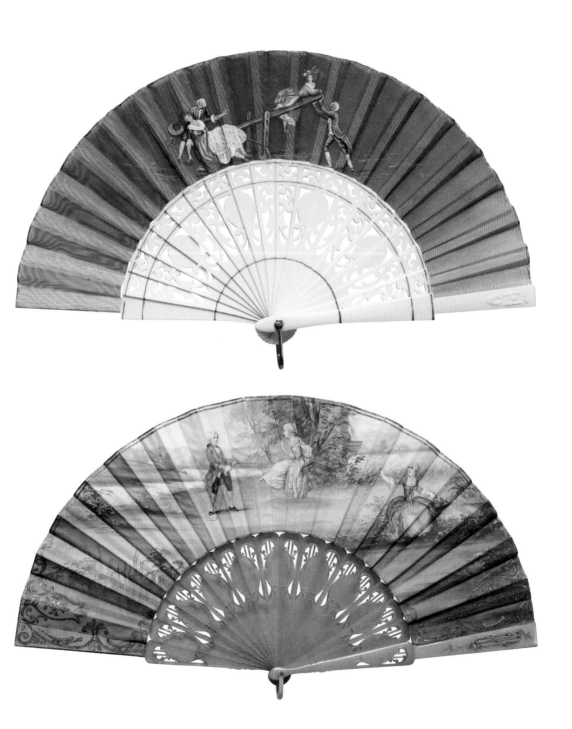

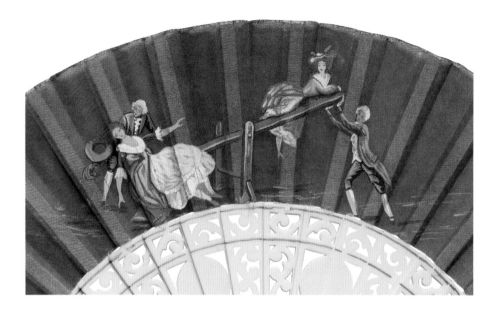

1-21. Painted organza and faux ivory fan, Europe (detail), early 20th century

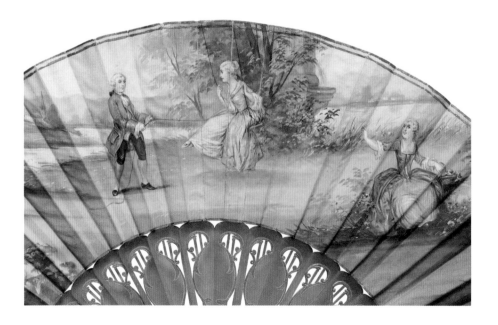

1-22. Painted fabric and celluloid fan, Europe (detail), 19th century

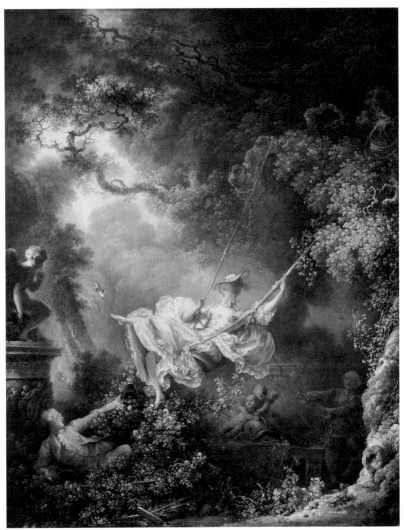

▲ Fig 13. Jean-Honoré Fragonard, *The Happy Accidents of the Swing*, 1767–1768, oil on canvas, 81 × 64 cm, Wallace Collection, London

**JENNY LIND FANS**
Europe, late 19th century

▲ 23: Fabric leaves painted with a "Conversation galante", pierced and piqué bone monture, silk tassel, 17.6 x 32.3 cm

▼ 24: Spangled pink silk leaves, pierced ivory monture, silk tassel, 27.7 x 51 cm

▲ This is a Jenny Lind Fan, which was popular throughout Europe and the USA from the middle of the nineteenth century. It is named after the Swedish opera singer who performed widely in the USA and Europe. This type of fan is characterised by its collection of wide, petal-shaped leaves which are sometimes decorated with feathers. The petal shapes are made of silk and the artwork is applied on top. The fan leaf illustrates a woman and a man engaging in a romantic conversation. Another woman on the right, wearing a country-style dress, is observing the scene. The red silk tassel stands out against the ivory coloured fan leaves. The fan sticks and guards are made of bone, decorated with carved openwork and piqué work.

▼ This fan's pink silk leaves are spangled and the guards, made of ivory, are decorated with plant-shaped carved openwork. It also has a silk tassel.

I-25

PAINTED VELLUM AND
MOTHER-OF-PEARL FAN
Europe, late 19th century

Painted in gouache with a romanticised
vignette, the sticks and guards
elaborately carved with stylised
motifs framing cameo reserves,
signed "de Nancourt", 29 x 53 cm

The fan leaf, painted in gouache on vellum, depicts two lovers dressed in romantic medieval attire enjoying a romantic rendezvous on the steps of a mansion house, against the backdrop of a lush green landscape. To the right of the lovers, a maid carrying a tray of drinks is looking back at them. The presence of an additional person observing the lovers is common in artworks depicting romantic scenes. Fan sticks and guards made of mother-of-pearl are delicately carved with floral ornaments and figures using the cameo* technique. The right side of the fan leaf is signed "de Nancourt".

---

* Cameo is a carving method for embossing translucent or opaque gemstones, mother-of-pearl and glass. It is characterised by dividing the background layer from a raised foreground layer. It is often used on ceramics and jewellery.

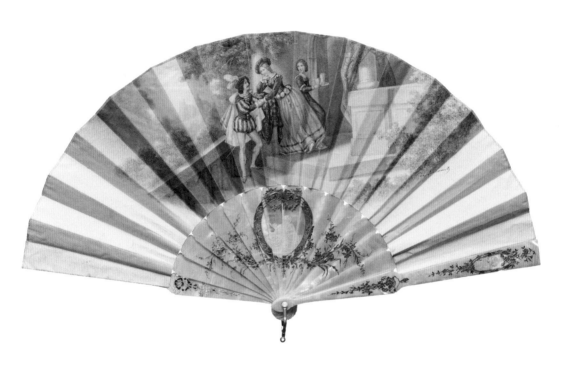

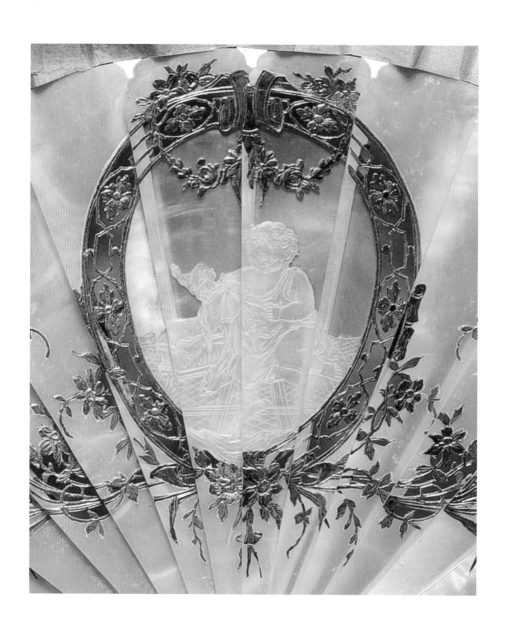

1-25. Painted vellum and mother-of-pearl fan (detail), Europe, late 19th century

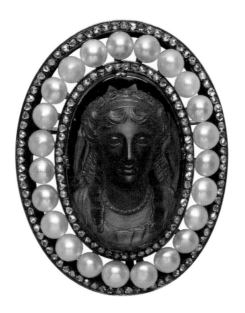

▲ Fig 14. Illustrious lady brooch, late 19th century, England, amethyst cameo, gold, silver, diamonds, pearls, 5.1 × 4.1 × 1.7 cm, Eurus Collection

## PAINTED VELLUM AND MOTHER-OF-PEARL FAN
### Europe, late 19th century

Painted with blossoms flanking
a Romantic vignette, signed
"Noujaret", 28.5 x 54 cm

The sticks and guards of this fan are made of mother-of-pearl. Its leaf, painted in gouache on vellum, depicts a man strolling in a park with his lover. The man is carrying a stringed musical instrument. The artwork uses the composition of a landscape painting, smoothly blending the views of varying distances. The close-range view depicts a flower in full bloom, symbolising the couple's liaison. The mid-range view shows the two lovers, while the distant view portrays a still lake and mountains, evoking a sense of elegance and tenderness. The top of the fan leaf's front side is signed "Noujaret". There is no artwork on the reverse side of the fan.

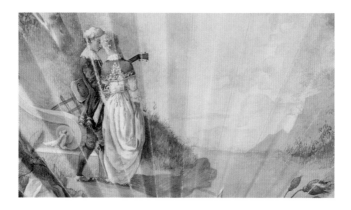

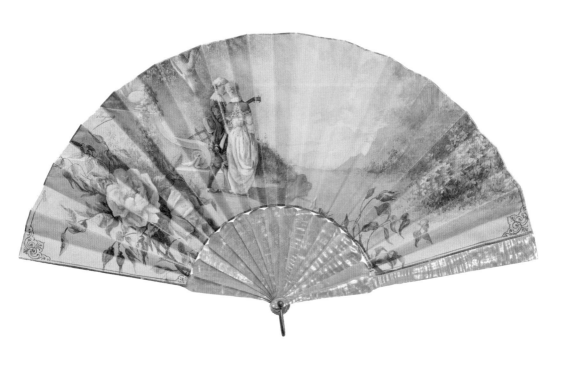

# PAINTED PAPER AND MOTHER-OF-PEARL FAN
## France, 1888

Painted with three Muses,
pierced monture, signed
"Max Guyon", 32 x 70 cm

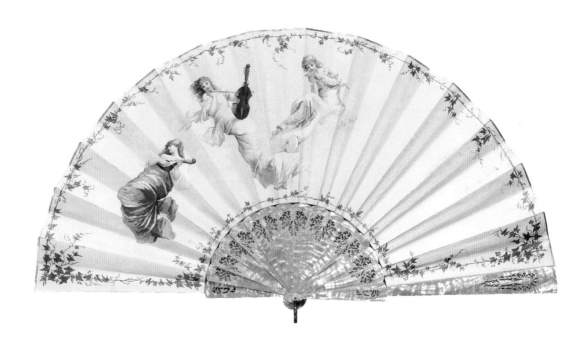

The sticks and guards of this fan are made of mother-of-pearl, elaborately pierced with repeated plant patterns. On the fan leaf, the artwork portrays three Muses in romantic and elegant poses, as if they are being lifted by the wind. Each of them is playing a musical instrument: a mandolin, violin and presumably a pan flute. The edge of the fan leaf is decorated with a vine pattern. Below the woman in a blue dress there is the inscription "Max Guyon".

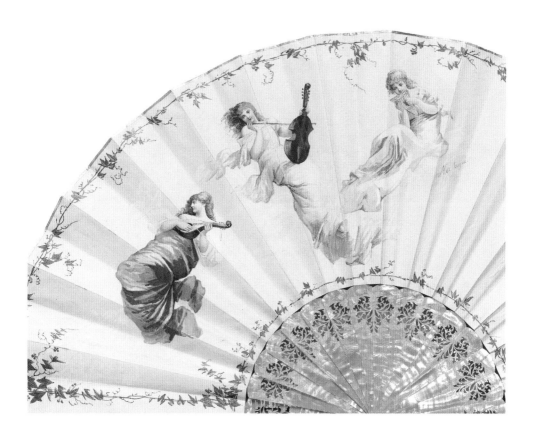

# 2. Joy of Hybridity

Cultural Exchanges and the Emergence of New Styles

## Joy of Hybridity

When elements from different civilizations and cultures come together, whether they are institutions or individuals, it is fascinating how their differences often become the driving force for creativity. One example of this is the hybridity in culture and the arts that emerged through encounters between the East and the West. These exchanges between civilisations took place from as early as the ninth century B.C., along grassland paths which eventually, in the second century B.C., became the Silk Road, an important trade route connecting Central Asia, the Middle East and the Mediterranean. The Silk Road enabled Buddhism, Gandhara art and Central Asian music to travel across to China and for Chinese silk, tea, ceramics and papermaking techniques to make their way to the West.

In the fifteenth and sixteenth centuries Europeans ventured across the sea to explore new routes and unknown lands. These expeditions were inspired by the travels to the East of the Venetian merchant Marco Polo (1254–1324), as well as by the Crusaders' desire to confront the Islamic powers in the Middle East. Exposure to the East meant not only cultural and technological gains, but also many other benefits – political, military, religious and economical. The Netherlands, England and France had each established an East India Company, which eagerly pursued exotic civilisations.

Driven by these events, folding fans from the East were introduced to Europe in the sixteenth century. By the early seventeenth century the exotic fans were either imported from the East or produced directly in Europe. Rare goods produced in the East were transported by sea in great numbers and were regarded as precious items. In France the aesthetics of the Chinese style, "chinoiserie",

became popular. Louis XIV was at the forefront of this trend and decorated part of the Versailles Palace in chinoiserie style. It quickly became fashionable among aristocrats, who were fascinated by the style's rare aesthetics. Upper-class Europeans started to decorate their surroundings with chinoiserie furniture, ceramics, wallpaper, paintings and fans, which increased the importation, production and development of Chinese-style crafts. This trend was facilitated by decorative arts dealers (*marchands-merciers*) whose business was importing works of art from the East and who also began to produce their own chinoiserie-like works. By the eighteenth century it was the hybrid aesthetic that resulted from European interpretation or imitation of Chinese style that was referred to as chinoiserie. This new hybrid style satisfied the decorative needs of the bourgeoisie as well as the aristocracy. Europeans' fascination with this exotic style continued to grow and peaked in the nineteenth century. In the 1860s Japanese art and crafts works became available in France due to the country's establishing diplomatic relations with Japan. Consequently Japanese style also became enormously popular, influencing the world of art and design in Europe. The phenomenon of this Japanese-inspired style was referred to as Japonisme by French art critic Philip Burty.

The Crusades were a series of conflicts between Western Europe and the Islamic world from the end of the eleventh century to the end of the thirteenth century. Started for religious reasons, the Crusades had various other motives, including adventure, curiosity and the desire for conquest. Expeditions to the Middle East facilitated the development of Eastern trade based in the Mediterranean. In addition, the expeditions offered a new

cultural stimulus for the West by exposing it to the highly advanced Islamic and Byzantine cultures. There was a cultural generalisation and mystification of the Eastern world by the West, referred to as "Orientalism". Although the concept had its roots in imperialism and colonialism, it was a significant influence on the arts and crafts of the period. The influence of Orientalism can be found in fans made in the early nineteenth to twentieth century, as seen in the proliferation of dancers, odalisques, Turkish clothes, arabesque patterns, mysterious animals and the crescent moon.

Hybridity of design can also occur with a merging of aesthetics from different historical periods. In the eighteenth century subjects and scenes inspired by ancient Greek and Roman mythology began to appear on fan leaves. Ruins such as Pompeii and Herculaneum excavated in the early eighteenth century stimulated the interest of the European upper-class and became a key part of the Grand Tour tradition in aristocratic education. The purpose of this tour was to give young, upper-class European gentlemen a chance to explore the ancient ruins of Italy and the metropolis where the Renaissance emerged, while learning the latest Parisian etiquette. This popular tradition led to the growth of the souvenir industry and new art and craft works were produced in Italy specially for travellers. These included fans decorated with ancient Greek and Roman artworks, which became popular souvenirs due to being easy to transport.

It is worth noting that from the late nineteenth century fans were increasingly used in advertising, demonstrating a hybridity between functions. The vast number of fans produced for perfume advertisements offers a glimpse into the consumption culture, aesthetic standards and lifestyle

of upper-class European women. In another example of functional hybridity, some fans included a lens and thus also functioned as opera glasses, opera being a popular form of entertainment among upper-class Europeans.

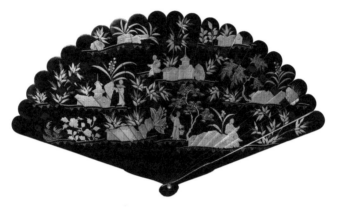

▲ Fig 15. Ebonised wood brisé fan for export to Europe*, mid-19th century, 20 x 32 cm, China, Eurus Collection

---

* This fan, which was made in mid-19th-century China for export to Europe, features Eastern figures and landscapes painted with gold powder on an ebonised wooden monture. Fans with gold decorated sticks were usually produced using a technique called *maki-e* in Japan in the 19th century. This technique is one of the traditional Japanese lacquer art methods and involves drawing a pattern with gold or silver powder and applying a coat of transparent paint over the top.

# PAINTED VELLUM
# AND IVORY FAN
## Europe, 18th century

Painted in gouache with a
Triumph of Neptune (Poseidon),
mounted *à l'Anglaise*, 27 x 40 cm

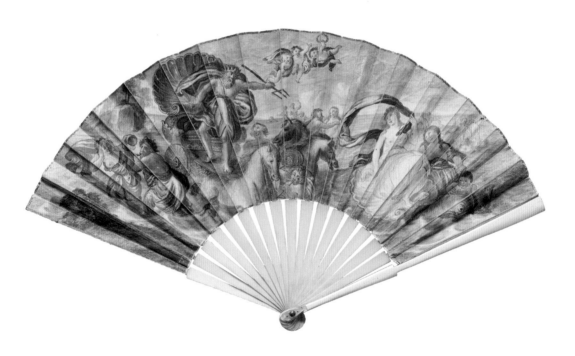

Fans containing Greek and Roman mythological and historical scenes began to appear around the eighteenth century. This fan depicts a Triumph of Neptune, the Roman god who ruled the seas, rivers and springs. In Greek mythology, he is referred to as Poseidon, a son of Cronus and Rhea and brother of Zeus. According to Roman mythology, Neptune lives in a palace under the sea, rides a Hippocampus to cross the sea and starts earthquakes by moving sea and earth with his trident. It is said that Neptune fell in love with Amphitrite, a sea nymph, and asked her to marry him. When she rejected his proposal, Neptune asked a dolphin to search for the sea nymph and persuade her to marry him. The scene on the fan depicts the story of Neptune's victory after Amphitrite accepts his second marriage proposal. The sea gods and nymphs gather round to celebrate his triumph and Cupids fly above carrying a wreath to symbolise the love and union of the couple.

The fan leaf is mounted *à l'anglaise*, which means a single leaf is mounted so that the ribs on the reverse side are visible. Usually the reverse side is entirely painted, but sometimes the ribs are painted separately for emphasis. The leaf is made of vellum,* a parchment made from calf skin, and painted in gouache. Painting in gouache on vellum was a technique used for luxury fans from the eighteenth century, until the lithograph technique became popular in the nineteenth century.

---

* Vellum is a writing material made of animal membrane from calves, sheep or goats. Sometimes it is interchangeably used with the term "parchment", which is a broader term for animal skins. The use of animal membrane as a writing material goes as far back as the 2nd century AD in the city of Pergamum (modern Bergama, Turkey), where the word "parchment" originated.

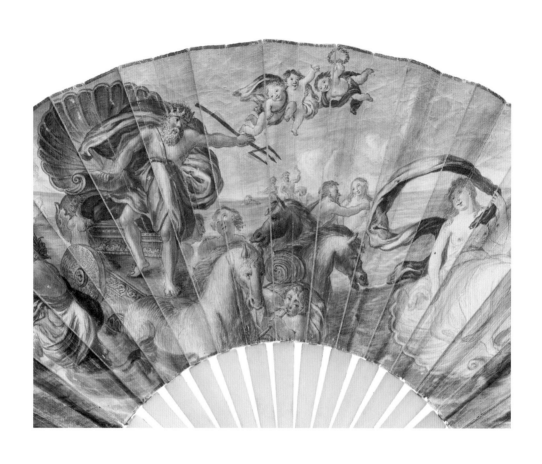

2-1. Painted vellum and ivory fan, Europe (detail), 18th century

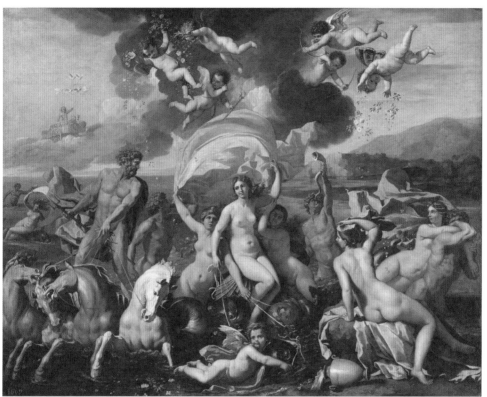

▲ Fig 16. Nicolas Poussin, *The Triumph of Neptune or The Birth of Venus*,* 1635 or 1636, oil on canvas, 97.2 × 108 cm, Philadelphia Museum of Art, Philadelphia

* The work by the French painter Nicolas Poussin was commissioned by Cardinal Richelieu, chief minister to King Louis XIII. The subject is widely debated and is believed to be either the Triumph of Neptune or The Birth of Venus. It is commonly interpreted that the painting symbolises the marriage between Neptune and Amphitrite, a daughter of Oceanus, who ruled over the outer sea that encircles the earth.

**2-2**

**PAINTED VELLUM
AND IVORY FAN**
Probably Italy, 18th century

Depicting Julius Caesar
divorcing Pompeia, embellished
with spangles, gold piqué
monture, 24 x 40.3 cm

The sticks and guards of this fan are made of ivory decorated with gold piqué work. The fan leaf, painted with gouache on vellum, illustrates an anecdote from the life of the Roman general and statesman Julius Caesar (100–44 BC). By the eighteenth century, with the excavation of ancient ruins in the preceding centuries, ancient sites and historical figures became frequently occurring subjects in fan leaf paintings. This scene illustrates Caesar demanding a divorce from his second wife, Pompeia, as rumours spread of her relationship with Publius Clodius Pulcher. Behind the two figures, columns and some items of furniture, in ancient Roman style, can be seen. To the right of Caesar, in the distance, is a soldier in Roman dress. The edge of the fan leaf is ornately decorated with gold spangles.

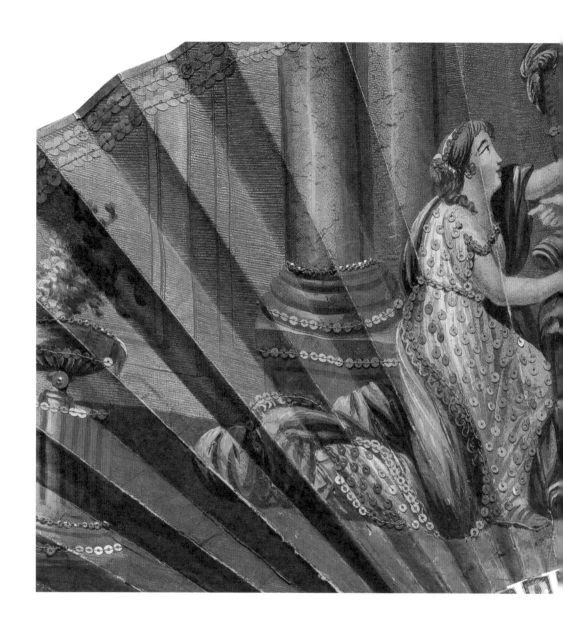

2-2. Painted vellum and ivory fan (detail),* probably Italy, 18th century

* The background story of Caesar's divorce is related to Pompeia hosting the festival of the Bona Dea (a goddess in ancient Roman religion who was associated with chastity and fertility). Although no men were allowed to attend the festival, Publius Clodius Pulcher disguised himself as a woman and managed to gain entrance. He was accused of seducing Pompeia, but was acquitted. Nevertheless, Caesar still divorced Pompeia, stating that "my wife ought not even be under suspicion" because he could not tolerate even the slightest possibility of her being unfaithful.

## POLYCHROME IVORY BRISÉ FAN
### Europe, early 18th century

Painted with "The Finding of Moses"
front and figures at leisure in a park
back, the guards with tortoiseshell head,
decoration refreshed, 21.5 x 30.5 cm

This brisé fan depicts the famous biblical story "The Finding of Moses". Moses is an important figure in the Old Testament who conveys God's laws and revelations to the people. Anecdotes related to Moses are common subjects in art and craft works. When the Pharaoh, king of Egypt, ordered all new-born Hebrew male infants to be killed, Moses's mother put her son in a basket and placed him on the bank of the River Nile in order to protect him. The artwork on this fan illustrates the scene from chapter two of Exodus where the Pharaoh's daughter and her maids find Moses by the riverbank and save his life. Each of the figures wears European eighteenth century-style dress and the background of the scene is reminiscent of a European village. On the lower part of the fan's front, two lovers are illustrated within a cartouche, a Rococo-style frame. The guards, some parts of which are made of tortoiseshell, are decorated in bright colours with reserves of figures, an urn and other stylised motifs. This fan is an interesting combination of the eighteenth-century Rococo motif and a biblical story. In the late seventeenth to early eighteenth century these small brisé fans were popular in Europe. Common subjects for their artworks were stories from the Bible, mythology and reproductions of famous paintings.

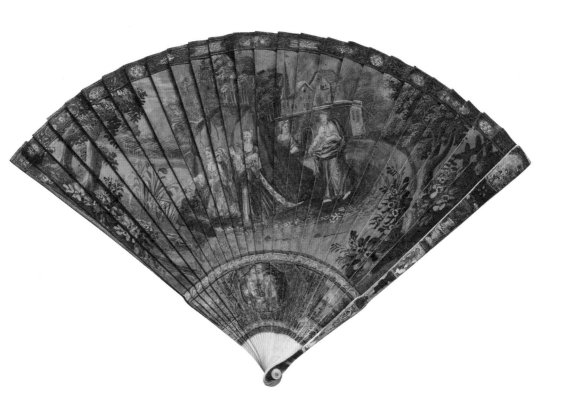

**2-4**

**PAINTED VELLUM
AND IVORY FAN**
Probably Italy, 18th century

Roman classical vignettes,
polychrome pierced
monture, 27 x 49.5 cm

This fan, whose sticks and guards are made of ivory, depicts on its vellum leaf a wedding scene with figures in ancient Roman attire. In the centre of the leaf, a couple take their marriage vows while two Cupids bless the event by holding wreaths and a torch. On the left, a woman is playing a tambourine and children are playing a flute to celebrate the wedding. On the right, witnessing the event, is a Roman soldier wearing a red cloak and holding a spear. The monture is elaborately pierced and coloured. The gorge, in particular, is pierced in a sophisticated manner with Rococo-style swirls and is divided into three parts. The centre part has shepherds and their sheep symmetrically sculpted; the background is ornately pierced. On the upper part of each guard, a soldier with a spear and shield is delicately sculpted.

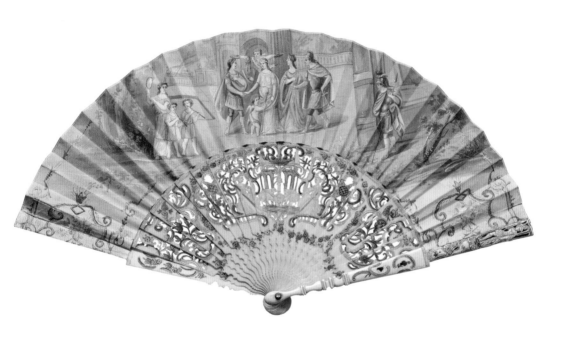

## CHINOISERIE PAINTED PAPER AND WOOD FAN
### Europe, mid-18th century

Painted in gouache with a Chinese-inspired vignette on *découpé* paper, polychrome-decorated wooden sticks and carved guard, 29 x 48 cm

This fan's wooden sticks and guards are elaborately sculpt-ed and its paper leaf is decorated using the *papier découpé* technique – an ancient technique that was widely used, particularly in China, for cutting shapes of people, objects and various patterns from a single piece of paper. The artwork portrays a figure that appears to be a child monk with a mythical animal resembling a lion walking through a garden featuring fantastically shaped rocks (known as "fantastic rocks") and blossoming trees. On the fan guards flowers and birds have been carved, then painted. The fan sticks are painted with human figures, a deer, birds and flowers.

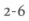

**2-6**

CHINOISERIE PAINTED
PAPER AND IVORY FAN
Europe, early 18th century

Painted with two asymmetric figural
cartouches interposed between
vignettes of European and Asian
figures in a continuous landscape,
the guard carved with a figure and
stylised motifs, 26 x 38.5 cm

This chinoiserie fan's sticks and guards are made of ivory and its leaf is painted on paper. In the centre and on the right side of the leaf there is an asymmetric cartouche featuring figures in Chinese attire – a mix of Qing-dynasty dress and Hanfu, the traditional Ming-dynasty female style of clothing. The border decorations frame the figures and are connected to tree patterns. At the top of the borders there are tree branches and birds. The centre of the leaf depicts a woman standing in a garden holding a fan in the shape of a palm-leaf. Behind her is another woman wearing blue attire and sitting next to a table made of "fantastic rocks" with a bonsai tree on it. On the left side of the leaf, against the backdrop of ancient Roman ruins, there are European figures in Roman attire standing and sitting next to a tree. The surface of the fan leaf sparkles, which is achieved by applying mother-of-pearl powder fixed with glue. This is a typical chinoiserie fan which mixes Eastern and European aesthetics within a single scene. In terms of its structure, this fan has a wedge shape (V-shape) that opens at a 45-degree angle, similar to Eastern fans. European luxury fans made in the early eighteenth century often followed this structure, suggesting that, like chinoiserie fan artworks, fan sticks and guards made by European makers were also influenced by Eastern fan structure.

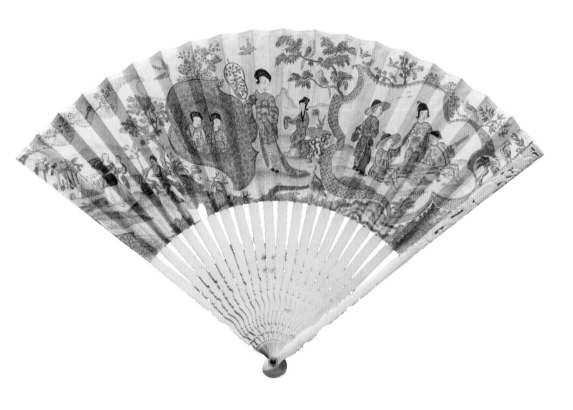

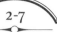

**2-7**

**CHINOISERIE APPLIQUÉD PAINTED SILK AND IVORY FAN**
Europe, mid-18th century

Decorated with a highly imaginative chinoiserie scene, the monture pierce-carved and painted in polychrome and metallic pigments with figures and stylised motifs, 24 x 50 cm

This fan's leaf is made of silk and depicts an artwork with chinoiserie figures. In the centre of the leaf is a main figure wearing Eastern-style attire and a black hat, sitting by a table with a bonsai tree on it and waiting for refreshments to be served by an attendant. The main figure is drawn larger than the attendant, with the composition following a hierarchical scale whereby the figure sizes are determined by their social status. Adjacent to the figures, there are "fantastic rocks" and exotic trees with flowers embellished with spangles and gold thread embroidery, completing the imaginary scene. The faces of the two main figures have vivid expressions created by using the appliqué technique, which involves attaching delicately drawn images from a piece of paper or cloth to the fan leaf. The sticks, which are made of ivory, and the guards are sculpted with human figures and geometric patterns and then painted with metallic, multi-coloured pigments.

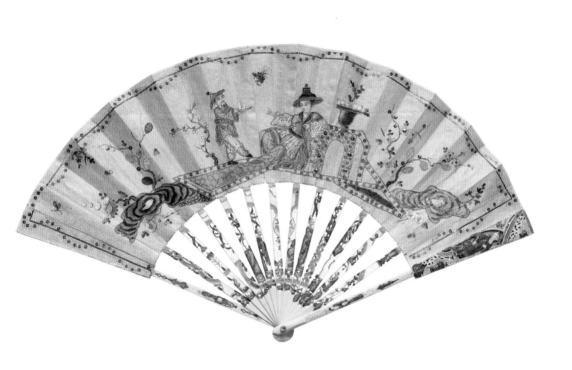

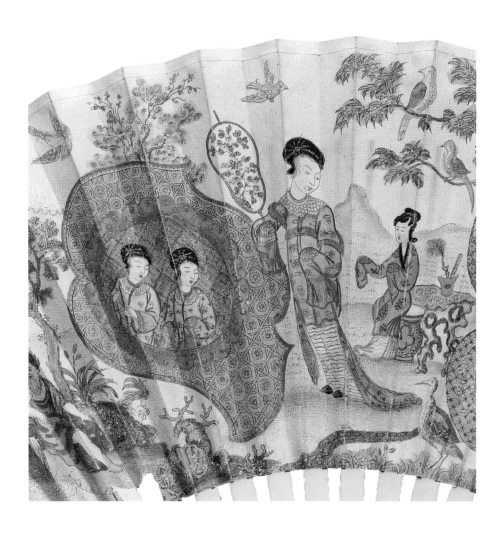

2-6. Chinoiserie painted paper and ivory fan, Europe (detail), early 18th century

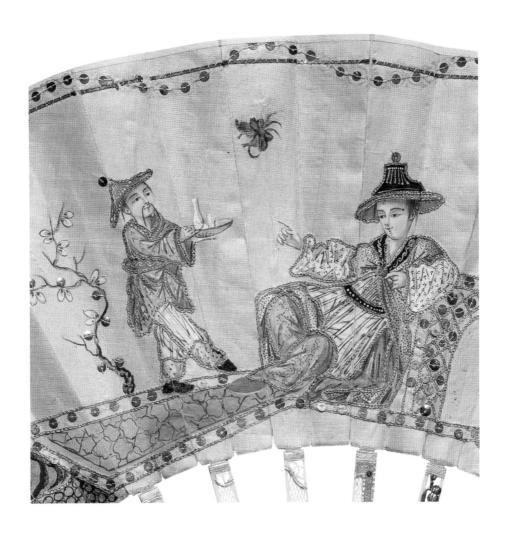

2-7. Chinoiserie appliquéd painted silk and ivory fan (detail), Europe, mid-18th century

**2-8**

CHINOISERIE PAINTED PAPIER-
MÂCHÉ AND WOOD FIXED FAN
Europe, mid-19th century

Gilt-decorated on red lacquered
papier-mâché, painted with
chinoiserie motifs, 40 x 26 cm

This fixed fan has a red lacquered fan screen, made using papier-mâché, and is fixed to a wooden handle. It is decorated in red and gold throughout. It was made for indoor use, to ward off heat from open fires or to protect from sunlight. Also known as a hand-screen fan, it was often made in pairs. Although made in Europe, this fan is influenced by traditional Chinese craft methods in its use of red lacquer and gold gilt. A Chinese pagoda and trees are depicted and the screen is cut in the shape of a leaf. Hand-screen fans were usually made using papier-mâché with multi-layered lacquer coatings, making them durable and versatile in shape.

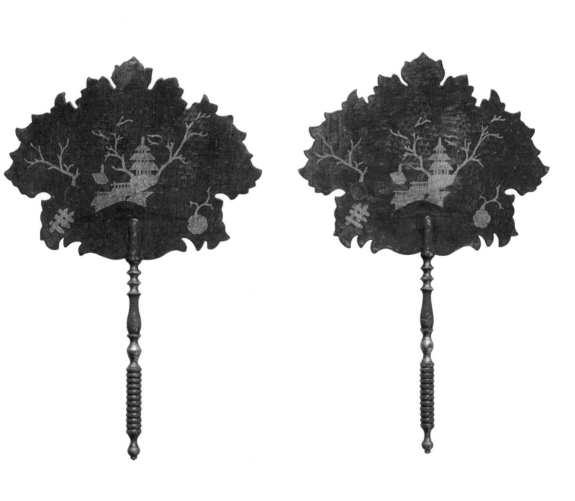

## 2-9

### PAPIER-MÂCHÉ AND IVORY FIXED FAN
### Europe, mid-19th century

Polychrome lacquered papier-mâché, mother-of-pearl inlay, 40 x 24.5 cm

This fan's screen is made of papier-mâché and its edges are cut in a repeated curved pattern. Flowers, trees and an exotic bird are colourfully depicted on the screen and the partial mother-of-pearl decoration adds to the fan's uniqueness. It is painted in brown tones and the plant stems and branches are rendered flowing down the screen. The handle is made of ivory and is elaborately carved with flowers and plants.

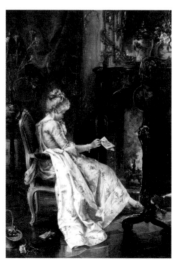

▲ Fig 17. Carl Herpfer, *The Love Letter*,* 19th century, oil on canvas, 63.5 × 45 cm

---

* In this painting a hand-screen fan can be seen hanging by the fireplace.

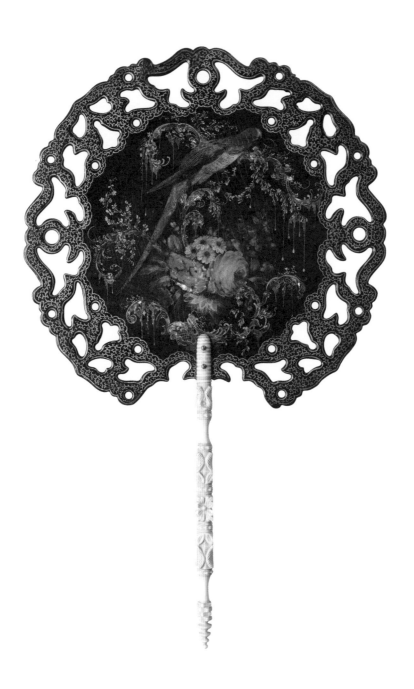

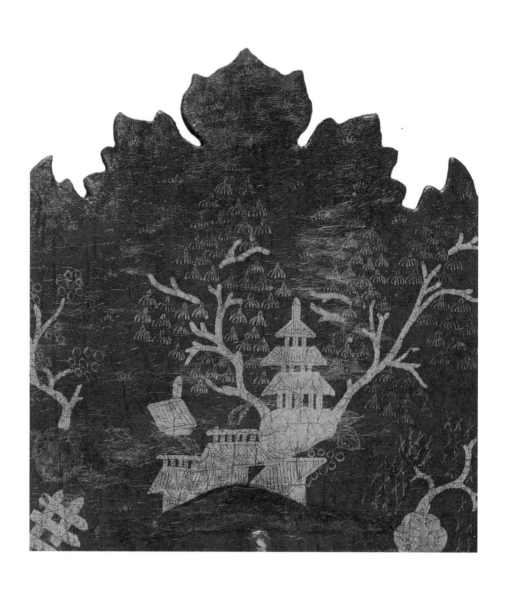

2-8. Chinoiserie painted papier-mâché and wood fixed fan (detail), Europe,
mid-19th century

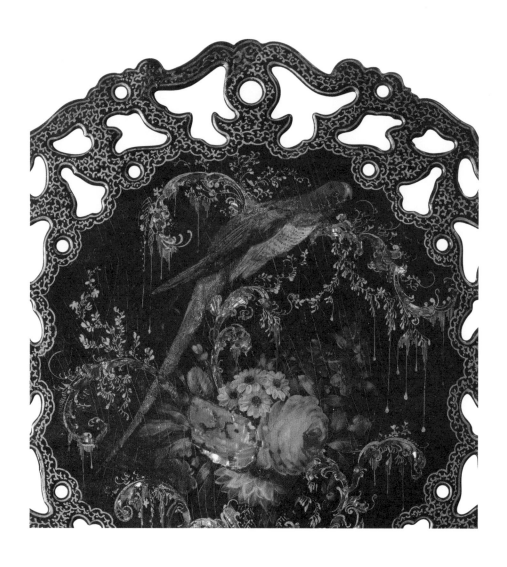

2-9. Papier-mâché and ivory fixed fan, Europe (detail), mid-19th century

## 2-10

### HAND-COLOURED LITHOGRAPHED PAPER AND BONE FAN
### Europe, late 19th century

Amazon hunt scene, pierced and piqué monture, 27.2 x 51.2 cm

This fan depicts a hunting scene with Amazons, a tribe of female warriors described in Greek mythology as courageous, physically strong and skilful in the arts of combat. On the fan leaf there are eight female warriors shooting bows and blowing horns against the backdrop of a blue sky and a forest. The artwork vividly illustrates a scene of a captain riding a chariot led by deer, with a group of women and hunting dogs following her. The reverse side of the fan leaf depicts a scene with two couples conversing in a garden, dressed in Louis XIII attire. Fans produced in the late nineteenth century often had two completely different scenes painted on their front and reverse sides. The fan sticks and guards are made of bone and decorated with patterned gold piqué work. The fan leaf is lithographically printed on paper and then coloured.

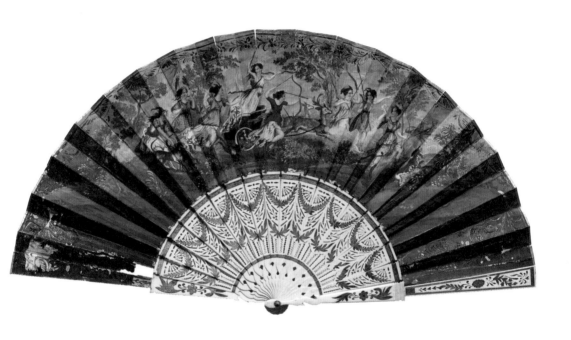

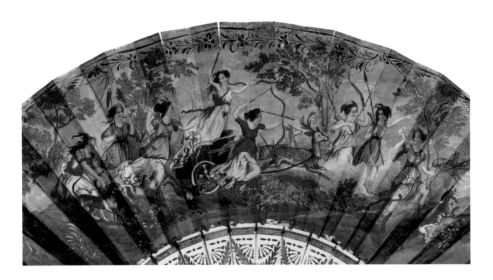

2-10. Hand-coloured lithographed paper and bone fan, Europe (detail), late 19th century

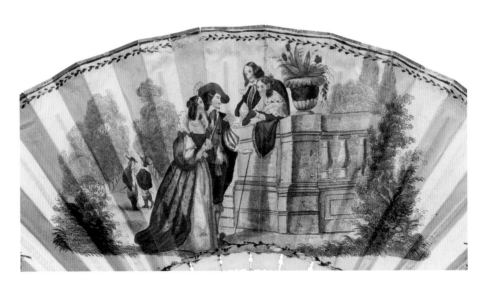

2-10. Hand-coloured lithographed paper and bone fan (detail reverse), Europe, late 19th century

▲ Fig 18. *Marble Statue of a Wounded Amazon*,
1st–2nd century AD, marble, 203.8 cm, The
Metropolitan Museum of Art, New York

## POLYCHROME
## TORTOISESHELL BRISÉ FAN
### Europe, 19th century

Centred by an oval reserve
depicting a group of three
bacchantes resting beneath
a tree, 15 x 27 cm

The oval shape at the centre of this fan depicts three bac-
chantes (female followers of Bacchus) resting under the
shade of a tree, with a wine jar and a tambourine adjacent.
Bacchus is the Roman god of abundance, vitality, wine
and ecstasy, corresponding to the Greek god, Dionysus.
Dionysus is often symbolised using the images of a grape
vine, ivy and apple trees. The top edges of the fan sticks
are decorated with gold grape vine patterns, and floral
patterns are elaborately depicted on the lower part.

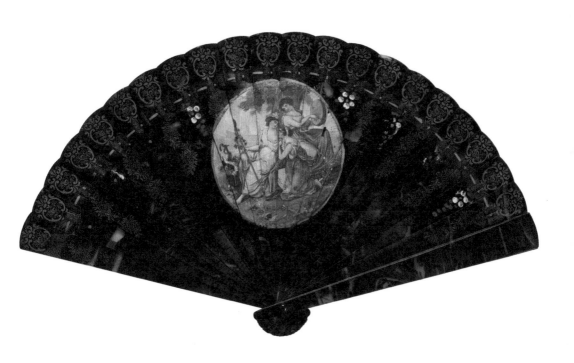

**PAINTED SILK AND HORN FAN**
Europe, early 20th century

Depicting an exotic dancer,
ivory guards and horn
sticks, 24.5 x 45 cm

This fan was made in Europe in the early twentieth century. Its sticks and guards are made of ivory. The silk fan leaf is painted with a striking image of a dancing woman wearing a purple dress, without any distinction between the fan sticks and the fan leaf. The woman appears to be absorbed in her dance and enjoying the moment. During the time of Louis XV in the eighteenth century, Europeans were fascinated by Turkish culture, and it was fashionable to recreate Turkish-style paintings and crafts. By the nineteenth century the influx of foreign cultures due to colonialism increased the desire to artistically represent what seemed exotic to Europeans. Women from the colonies were a particularly interesting subject and were depicted as mysterious, sensual figures in artistic representations.

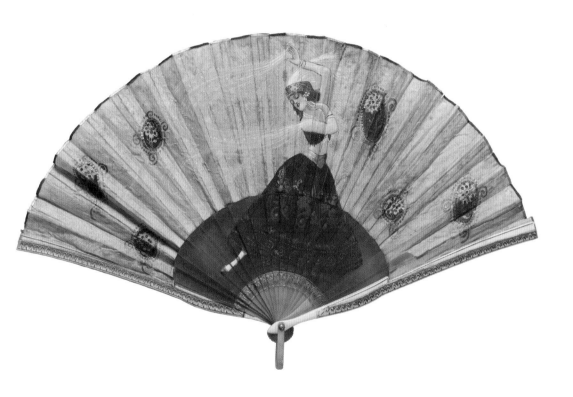

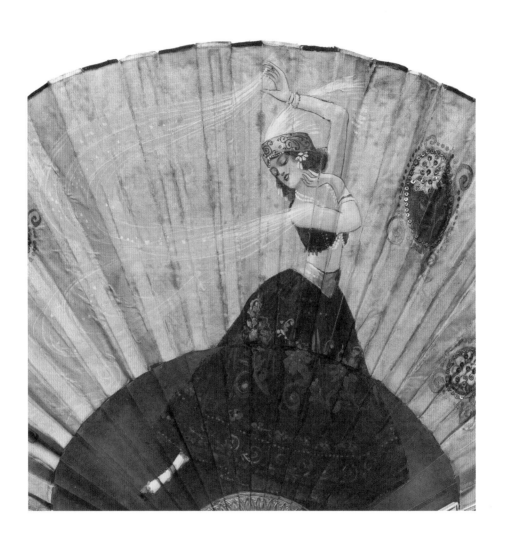

2-12. Painted silk and horn fan (detail), Europe, early 20th century

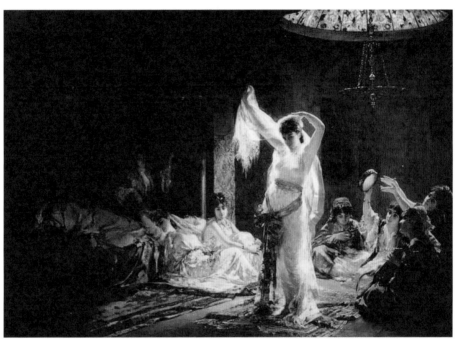

▲ Fig 19. Édouard Frédéric Wilhelm Richter, *The Sultan's Amusement*, 1877, oil on canvas, 140 × 180 cm, Instituto Ricardo Brennand, Recife, Brazil

## PAINTED BLACK SILK GAUZE AND FAUX TORTOISESHELL FAN
### France, 1905

Fontange-shaped fan painted
with gouache, signed "J. Kaheim"
and inscribed "Duvelleroy-
Paris", 35.5 x 44 cm

This fan is characterised by its fontange* shape, reminis-
cent of a high headdress, and its relatively narrow angle
when opened compared to other fans. The fan sticks are
made of imitation tortoiseshell and the leaf gouache
painting depicts a Turkish odalisque. She lies on her bed
at an angle, gazing at an exotic blue peacock. In the back-
ground is the exterior of a palace and a crescent moon, a
symbol of the Ottoman Empire which Europeans com-
monly associated with Islam. The word *odalisque* originates
from the Turkish word *oda* (meaning "chamber") and it
refers to a female attendant at a Turkish palace. In Europe,
however, it came to mean a harem concubine. Therefore,
when represented by European male artists in particular,
odalisques were often portrayed as erotic fantasy figures.
On the left of the fan leaf the artist's name "J. Kaheim"
is inscribed; on the reverse side is the maker's mark
"Duvelleroy-Paris".

---

* A fontange was a fashionable headdress among European upper-class women in the late 17th to early
18th century, characterised by its elevated shape. It is said that when the Duchesse de Fontange, a
mistress of King Louis XIV, lost her cap while out hunting with the king, she curled her hair up using
a ribbon. The king was enchanted by the style and it became fashionable. The hairstyle spread
throughout Europe and developed into various arrangements and trends. It eventually fell out of fashion
in the early nineteenth century.

**2-14**

**PAINTED SILK AND WOOD FAN**
Europe, probably 1870s

Cutaway and backed with silk gauze to
form peep holes, the ebonised monture
printed with stylised motifs in pastel
and metallic tones, 38 x 65.5 cm

This late nineteenth-century fan's sticks and guards are
made of ebonised woods and decorated with flowers,
plants and geometric patterns in gold and pastel shades.
The silk fan leaf depicts a woman looking through opera
glasses. Fascinatingly, there are peep holes, covered with
sheer silk in the lens of the opera glasses, so that the
owner of the fan could actually peek through them. In
the late nineteenth century opera houses were at the peak
of their splendour and hugely popular in Parisian social
circles. Patrons of the opera wore their finest attire and
took advantage of the opportunity to show off publicly
their appearance and flaunt their social status. They used
opera glasses not only to watch the performance, but also
to observe other people. The fan illustrates an aspect of
social playfulness from the late nineteenth century.

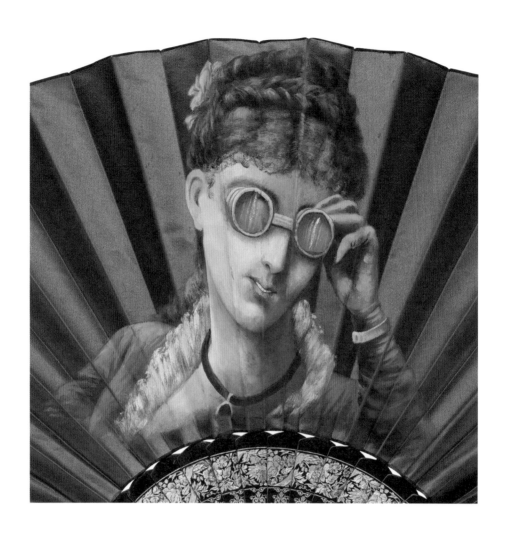

2-14. Painted silk and wood fan (detail), Europe, probably 1870s

▲ Fig 20. Mary Cassatt, *In the Loge*, 1878, oil on canvas, 81.28 × 66.04 cm, Museum of Fine Arts, Boston

**IVORY COCKADE FAN**
Europe, early 19th century

Elaborately pierce-carved
sticks and guards, 23 x 17 cm

This cockade fan, which takes a circle shape when opened, does not have a separate leaf and the flat sticks are connected with a ribbon. The entire fan is made of ivory, pierced and carved with elaborate repeated patterns. The guards are long and can therefore act as a handle when they meet at one point as the fan is closed. The fan has a telescopic lens at its centre, for use by opera goers. Fans with such hybrid functions were commonly produced during the early nineteenth century.

▲ Fig 21. Rudolph Ackermann, *Ball Dress*,* 1825, fashion plate, hand-coloured engraving on paper, 27.94 × 21.59 cm, Los Angeles County Museum of Art, Los Angeles

* The artwork depicts a woman holding a small cockade fan while attending a ball in the early 19th century.

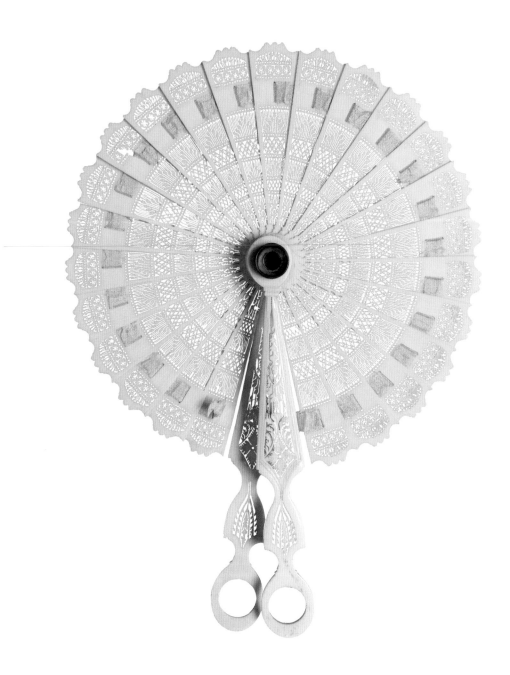

## 2-16

### "GOLDEN LINKS CALENDAR" FAN
### Germany, 1892

Inscribed on the front with an
excerpt from a poem on friendship,
stamped back "International Art
Publish. Co. Ltd., New York, Berlin,
Printed in Germany", 25.3 x 47 cm

This calendar fan was made by International Art Publishing Company Limited, based in New York and Berlin. The fan leaf depicts four elegant women and an inscription at one end which reads, "Well chosen friendship, the most noble of virtues, all our joys make double, and into halves divides our trouble. Sir J. Denham". This is a verse from a poem, "Friendship and Single Life, Against Love and Marriage", written by the Anglo-Irish poet Sir John Denham (1615–1669). The fan was produced in the 1890s, during the period before the First World War (1914–1918) known as "La Belle Époque". It was a time when Europe, France in particular, was peaceful, prosperous and filled with optimism. Meanwhile, in England, this period witnessed a transition from the Victorian to the Edwardian era, when science and technology were advancing after the Industrial Revolution.

It was during this time that the idea of the "new woman"– independent, university educated and actively participating in the workforce – began to emerge. In the cultural context of the time, therefore, the inclusion of the verse from Sir John Denham's poem, written nearly two centuries earlier, along with the images of four women, conveyed an empowering message to women, emphasising the value of female friendship and solidarity.

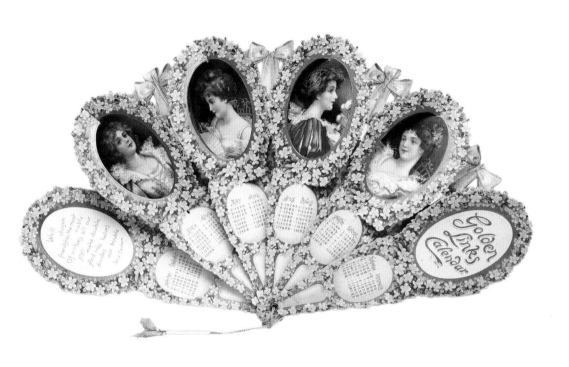

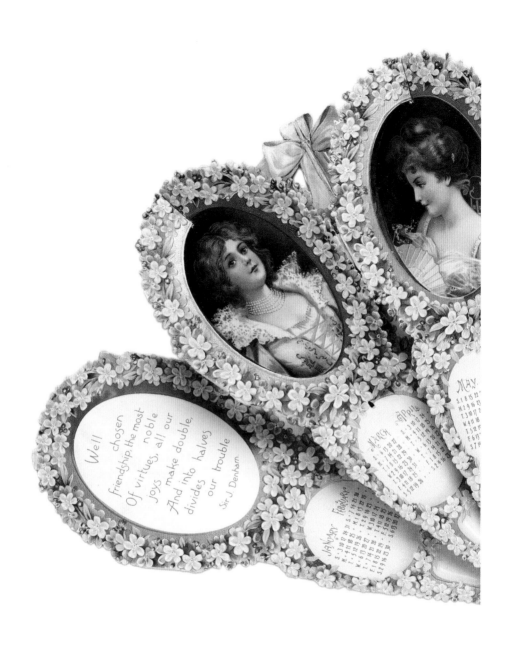

Well
chosen
friendship the most
noble
Of virtues, all our
joys make double,
And into halves
divides our trouble

Sir J. Denham.

2-16. "Golden Links Calendar" fan (detail), Germany, 1892

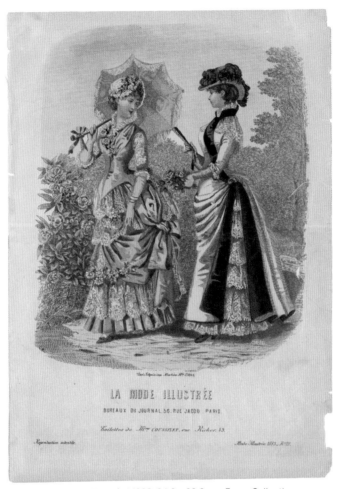

▲ Fig 22. *La Mode Illustrée*,* 1883, 34.9 x 23.9 cm, Eurus Collection

---

* By the late 19th century fashion magazines such as *La Mode Illustrée*, *Le Follet* and *Journal des Demoiselles* had been published in Paris and distributed to the rest of Europe. The magazines printed images of women wearing fashionable clothes, with fans appearing as a must-have accessory.

**2-I7**

HAND-COLOURED LITHOGRAPHED
PAPER AND WOOD FAN ADVERTISING
THE PERFUME "AZUREA"
France, early 20th century

Painting of a woman with a dog,
inscribed "Parfum Azurea" and
"L.T Piver Paris", 25 x 45 cm

This fan was made to advertise the perfume "Azurea". Its sticks are made of wood. The fan leaf, lithographed on paper and painted, depicts a woman lounging on a hillside against a sunny coastal background, holding a flower to her nose. She is accompanied by a small Jack Russell terrier. Printed on the lower right side of the fan leaf is the name "L. T. Piver", a traditional French perfume manufacturer still in business today. These mass-produced fans for advertising were made of cheap wood without decoration, with leaves printed or manufactured using thick compressed cardboard. This is a typical example of such a fan.

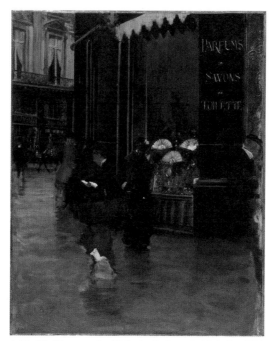

▲ Fig 23. Giuseppe De Nittis, *La Parfumerie Violet*,* c. 1880, oil on canvas, 40.5 x 32.5cm, Musée Carnavalet, Histoire de Paris, Paris

---

* This late 19th-century painting depicts a woman stopping to look at a showcase on a Paris street in which items such as fans, perfumes, soaps and cosmetics are displayed.

**2-18**

LITHOGRAPHED PAPER
COMMEMORATIVE FAN
France, c.1848

Printed in black with portrait
busts of the provisional
government of 1848, 22 x 40 cm

This is a commemorative fan made for political publicity. It reflects the rapidly changing political landscape in France during the nineteenth century. While the fan's precise production year is unknown, its content suggests that it was made around the time of the 1848 revolution. The figures depicted on the fan leaf are eleven ministers of the provisional government that was put in place immediately following the revolution in February of that year. From the left, they are Alexandre Martin, Ferdinand Flocon, Adolphe Crémieux, François Arago, Alphonse de Lamartine, Jacques-Charles Dupont de l'Eure, Alexandre Ledru-Rollin, Louis-Antoine Garnier-Pagès, Pierre Marie de Saint-Georges, Armand Marrast and Louis Blanc. Their names and portraits are lithographed on the fan leaf. Such commemorative political fans were also produced during the French Revolution in 1789.

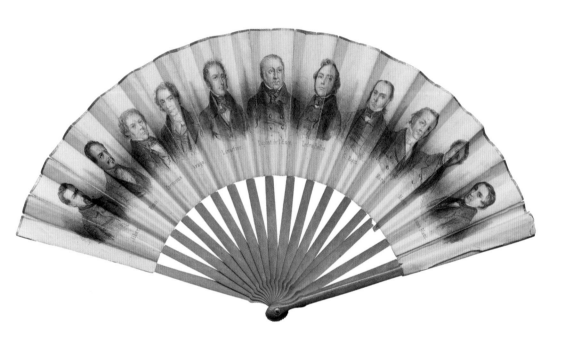

## POLYCHROME WOOD
## BRISÉ SOUVENIR FAN
### Switzerland, mid-19th century

The pierced sticks and guards
with reserves of women in regional
costume, inscribed in ink with the
name of the canton and headed
by the coat-of-arms, 23.5 x 41 cm

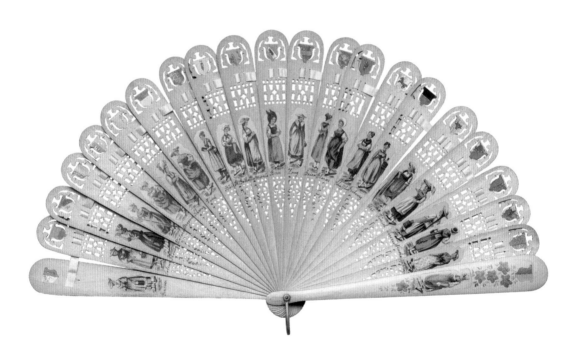

Represented on this brisé fan are the 22 cantons of Switzerland (26 in the present day), illustrated by women in regional costumes, each woman representing a canton. Industrialisation and the development of transportation in the nineteenth century led to the emergence of the modern package tour and the creation of travel companies, such as Thomas Cook, to tour the mountain regions of Switzerland, England, Italy and France. This kind of fan was prized as a souvenir by European travellers on tour.

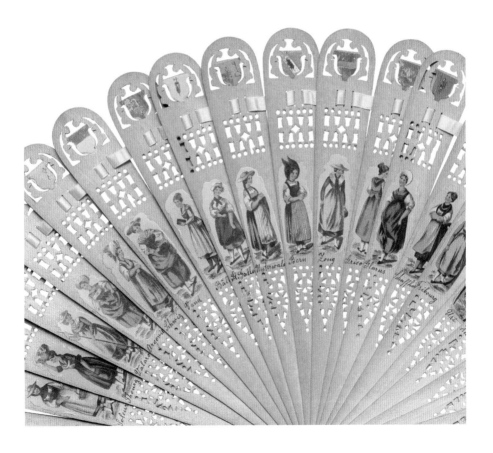

# 3. Versatility and Invention

Materials and New Techniques

# Versatility and Invention

In the sixteenth century Europe was undergoing economic expansion and moving into a more modernised era. This transition meant changes to all aspects of life, including the material culture. Although social class and hierarchy remained relevant, it was now possible for ordinary people to accumulate wealth and enjoy luxury goods. These goods were indicators of their owners' social status, and this stimulated the drive to purchase and own them. Fans were among those desired objects since they were considered both novel, as they showcased techniques of both the East and West, as well as being prized for their decoration with expensive materials such as ivory, tortoiseshell, bones, horns, mother-of-pearl, gold, silver and gems. Rare and valuable fans were popular collectible items for royal families, nobles and the bourgeois, not only symbolising wealth and power but also satisfying people's curiosity about the new world.

Considerable skill and craftsmanship were required in fan production. In the late seventeenth century the fan artisans, who were active mainly in France, with the formation of the guild of fan-makers, established a system of the division of labour, allowing specialisation in the production of fan leaves and fan sticks. Published approximately between 1751 and 1766, Diderot's *Encyclopédie* described the manufacturing process of the various aspects of fan-making in great detail. It provided precise instructions for fan leaf production, including creasing, painting and decorating of the leaf, as well as assembly of the fan and production of fan sticks.

In order to create the fan leaf, high-quality and durable materials such as vellum, silk and paper were necessary, so that fan-painters could paint onto it with gouache and watercolours. For fan leaf decoration,

symmetry was the general aesthetic standard, with the left and right sides of the fan spaced appropriately. To enhance the decoration, spangle or lace were used. These design decisions were entirely down to the artists' discretion and thus fan artists became recognised as experts and were able to sign their work.

▲ Fig 24. Plates illustrating fan-making from *Encyclopédie*, c. 1751–1766, by Denis Diderot,* engraving on paper, Smithsonian Design Museum, New York

The production of fan sticks was completely separate from the production of the fan leaf. It was usually material technicians who made fan montures (the fan sticks and guards). The technicians delicately carved the montures and decorated them using gilt, lacquer and inlaid techniques. Brisé fans demonstrate the skills of material technicians particularly well since these fans do not have pleated leaves. In France, so as to ensure the highest

---

* Denis Diderot (1713–1784), a French writer and philosopher, and Jean Le Rond d'Alembert (1717–1783), a French mathematician and philosopher, recruited over 140 renowned scholars and thinkers to publish a general encyclopaedia to spread knowledge and Enlightenment ideas. It was a monumental project which took over 40 years and consisted of 28 volumes.

quality of fans, it was mandated that material technicians could only specialise in making montures and they were not allowed to produce fan leaves. In England, on the other hand, the division of labour for fan-making artisans was not so clearly defined, so the same artisans could make fan leaves and montures, although fan leaf painters worked separately.

Production of the finest fans required not only skilled craftsmanship and colourful decoration, but also quality materials. Various rare materials were used to make fans, among which ivory, mother-of-pearl and tortoiseshell were most frequently used. However, since these materials were expensive and not always readily available, more affordable materials, such as animal bones and horns, were sometimes used as substitutes. In the eighteenth century French and Belgian lace, woven using various techniques, was also used in fan-making. Belgian lace was especially popular due to its particularly sophisticated and delicate technique using fine threads. In the early nineteenth century, with the advent of lace-weaving machines, mass production of lace became possible, but the machine-made lace could not match the quality of its sophisticated handmade counterpart.

Various types of silk were also used in fan-making. To accentuate silk's luxurious texture and colour, simple decorations were applied, mainly flowers and birds either painted or embroidered on. During the time of the Revolution in France, the production of fancy fans decreased. However, after the Revolution, many fans were produced using light and elegant materials such as simple and luxurious silk, lace and gauze. In the mid-nineteenth century feathers, the material found in the earliest Egyptian and Chinese fans, became popular again in Europe.

Ostrich feather fans that matched the colour of an outfit were popular, with their sticks and handles usually made of mother-of-pearl, ivory or tortoiseshell. In addition, due to the development of a type of plastic – celluloid – in the nineteenth century, the moulding and processing of fan sticks became easier. Moreover, the use of paper instead of expensive vellum allowed fan leaves to be patterned and printed using lithography. These changes in materials enabled mass production and reduced production costs.

**IVORY BRISÉ FAN**
Germany, 1870s

Elaborately carved sticks
and guards, 41 x 23 cm

The centre of this nineteenth-century ivory brisé fan depicts two angels in symmetry blowing trumpets while holding a veil between them. The guard on the front of the fan is sculpted in relief, and portrays a goddess decorated with flowers who is assumed to be the goddess Flora, symbol of fertility and the season of Spring. The guard on the back of the fan is delicately sculpted with flowers, ribbons and tassels. Compared to folding fans with simple fan sticks, these are sophisticated ivory guards and sticks interwoven with a silk ribbon. This fan was probably made in Erbach, Germany, a city that was famous for making ivory fans in the late nineteenth century. Ivory, the main material here, is made from elephant tusks, and its colour and smooth finish made fans durable while giving a luxurious appearance. High-quality ivory has been treated as a precious material since ancient times and used to make lavish crafts. However, after several decades of global efforts to ban the reckless capture of elephants, crafts made of ivory have become a thing of the past.

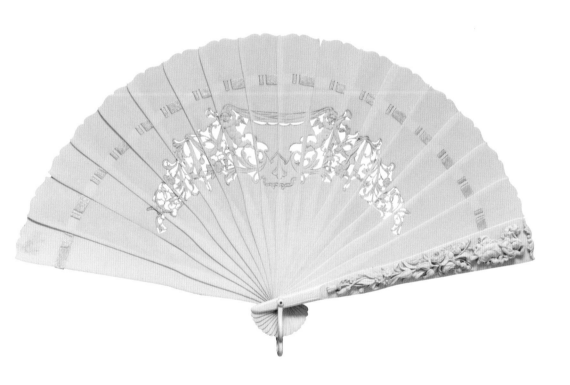

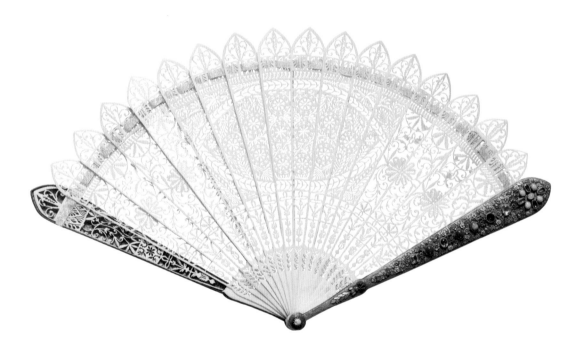

Across the entirety of the fan sticks of this brisé fan, floral and plant patterns are pierce-carved, as delicate as lace. The guards are decorated with gilt, diamond, emerald, blue sapphire, amethyst and semi-precious stones. Around the gemstones there are flowers thinly sculpted in metal, ornamenting the whole length of the guards. At the lower end of the guards, turquoise is stubbed on the pivot. These types of high-quality fans were frequently offered as gifts at the weddings of royal families and the nobility.

▲ Fig 25. John Dawson Watson, *An Elegant Woman with a Fan*, 1871, pencil and watercolour on paper, 45 × 35.5 cm, The Maas Gallery, London

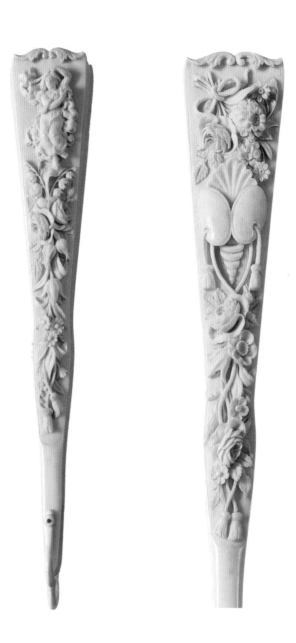

3-1. Ivory brisé fan, Germany (detail), 1870s

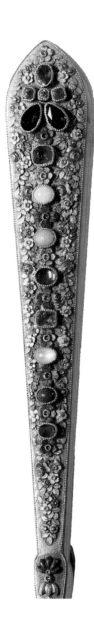
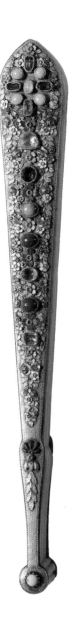

3-2. Ivory brisé fan, England (detail), 1830

**TORTOISESHELL BRISÉ FAN**
Europe, 19th century

The principal guard applied
with gilt-metal tracery set with
cabochon garnets and turquoise
gemstones, 21.5 x 38 cm

This brisé fan is characterised by its guards which are decorated with elaborate tracery, an architectural device that can be seen in Gothic-style windows. Around the tracery, decorated with gilt, cabochon-cut* turquoise and garnets are gorgeously ornamented. Tortoiseshell, the back shell of a tortoise, is the main material. Since ancient times, tortoiseshell has been regarded as a precious material for crafts because of its pliability when heated and its unique translucent and mottled patterning. It is said to have been imported from Egypt to Europe via Rome. André Charles Boulle (1642–1732), the seventeenth-century French furniture maker under Louis XIV, was known to have used tortoiseshell often for furniture, fixtures and jewellery boxes for the Palace of Versailles.

---

* Cabochon-cut is a type of cut used for gemstones and it refers to a technique that polishes the surface of the gemstone into spherical (convex) shapes.

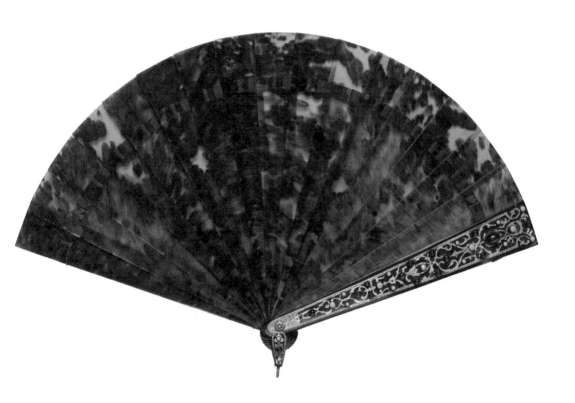

▲ Fig 26. Anonymous, *Designs for Gothic Tracery*, c. 1805, pen and black ink, 26 x 42.3 cm, The Metropolitan Museum of Art, New York

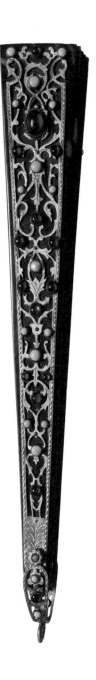

3-3. Tortoiseshell brisé fan (detail), Europe, 19th century

## POLYCHROME HORN BRISÉ FAN
### France, c. 1820–1830

Polychrome floral
decoration, 19 x 28 cm

This brisé fan was made using the horn-working technique. This technique uses primarily the horns of cows, but also those of sheep and goats. The fan's monture, pierce-carved with plant patterns, is decorated with a variety of colourful flowers in repetition. The horn-working technique involves applying heat and pressure to animal horns in order to manipulate their shape. Due to their scarcity and the difficulty of the processing technique, the use of animal horns to make crafts, although practised since ancient times, has been a special endeavour. This fan is a precious example of elaborate openwork and sophisticated craftmanship on compressed horns.

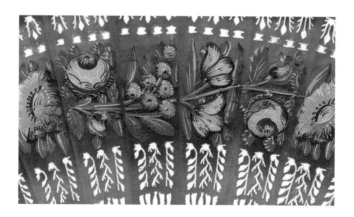

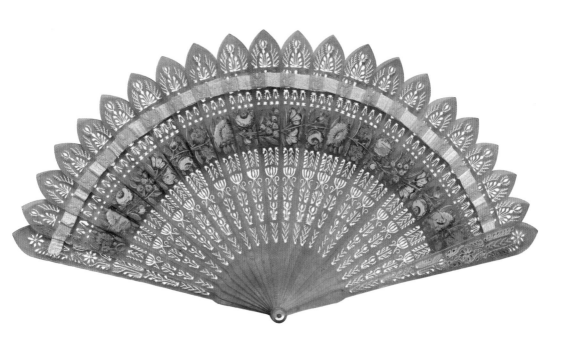

**WOOD BRISÉ FAN**
Europe, probably
late 19th century

Wooden sticks decorated
in découpage with diverse
images, 23.5 x 41 cm

This brisé fan is characterised by its découpage, a technique involving attaching paper cut-outs onto an object to give the impression of a painting. On the upper part of each wooden fan stick, and around the fixing ribbon, cut-outs of various images have been attached, including humorous portraits, angels, flowers and plants. When lacquer furniture from the East was introduced to Europe in the seventeenth century, découpage became fashionable and was in high demand. To meet that demand, it is said that Venetian artisans started to attach paper cut-outs to furniture and applied varnish to replicate the lacquer effect. In the early days of découpage, wrapping paper and cut-outs of readily available illustrations, including those from magazines, were used. In the eighteenth century this technique was used to attach imitations of Old Master paintings onto furniture made for royalty and the aristocracy. Découpage went on to become popular throughout Europe in art and craft making of all kinds, regardless of social class or status.

**3-6**

SPANGLED AND EMBROIDERED
SILK AND BONE FAN
Europe, 19th century

Embellished with spangles and
backed with silk gauze; the monture
carved with stylised motifs and picked
out in silver, gold and pastel tones,
with twin silk tassel, 21.5 x 37.5 cm

This is a folding fan whose sticks and guards are made of bone, carved in a sophisticated way with floral patterns and picked out in gold and silver. Bone as a craft material most commonly refers to cow bone, though the bones and horns of other animals may also be used. The silk gauze fan leaf is layered with pieces of silk which are decorated with spangles and embroidered works. This fan, dominated by floral and plant patterns in gold and silver, is striking due to the combination of different materials and textures. Two tassels made in the same colour as the fan add to the ornamentation. The use of bone for craft works has been practised since ancient times; it has been used as a substitute for ivory as it is relatively inexpensive, while sharing visual similarities. However, with the development of celluloid in the 1870s, both ivory and bone were gradually replaced in craft making by this new material. Subsequently bone fan production declined significantly.

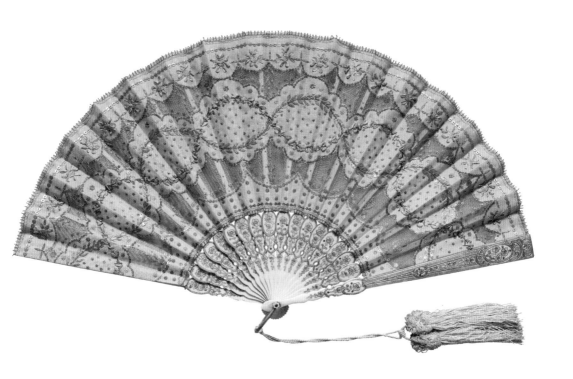

3-7

▲PAINTED RED SILK AND
MOTHER-OF-PEARL FAN
Europe, 19th century
Highly decorative mother-of-pearl
sticks on top of red silk, 21.5 x 40 cm

3-8

▼EMBROIDERED SILK AND
MOTHER-OF-PEARL FAN
Europe, 19th century
Worked with sprays of flowers in
pastel silk thread, the piqué monture
with stylised motifs, 27 x 49.5 cm

▲ This red silk fan with mother-of-pearl sticks is characterised by its exposed ribs over the silk leaf. On the leaf there are three types of floral patterns painted in repetition, balanced with other decoration on the mother-of-pearl ribs. The edge of the leaf is finished with lace. Mother-of-pearl is a material made by processing the inside of seashells. Due to its durability and iridescence, it has been used as a material in the making of high-quality crafts since ancient times. Mother-of-pearl artefacts date back as far as Shang dynasty China (1600–1040 BC); they were widely used during the Qing dynasty (1644–1912), often in combination with lacquer. It is also reported that mother-of-pearl was used to decorate the Golden House of Roman emperor Nero (reigned AD 54–68).

▼ This silk fan is embroidered with silk thread on its leaf. The monture, made of mother-of-pearl, is delicately decorated with foliage patterns. The refined plants embroidered on the leaf create an overall elegance by using a mixture of milky-white and light-green silk threads. The combination of silk and mother-of-pearl was often used in high-end fan production in the nineteenth century.

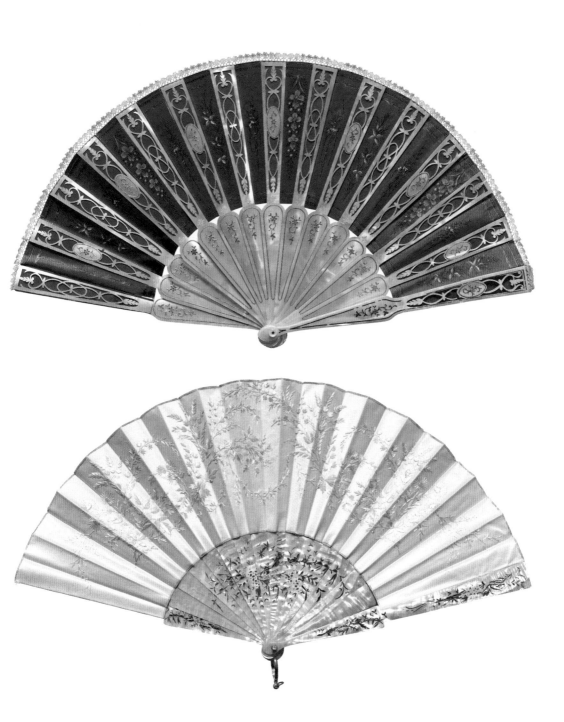

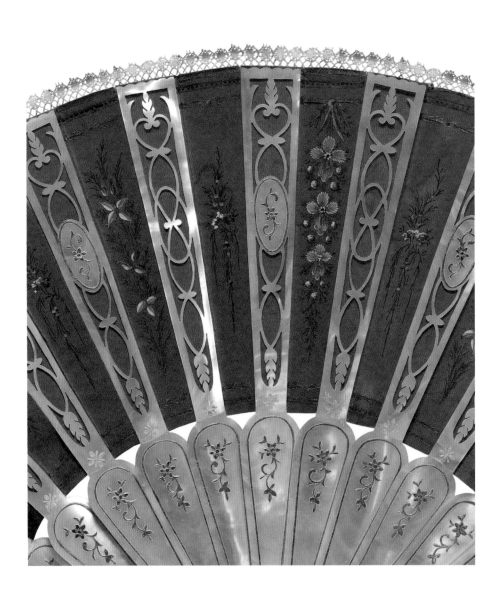

3-7. Painted red silk and mother-of-pearl fan (detail), Europe, 19th century

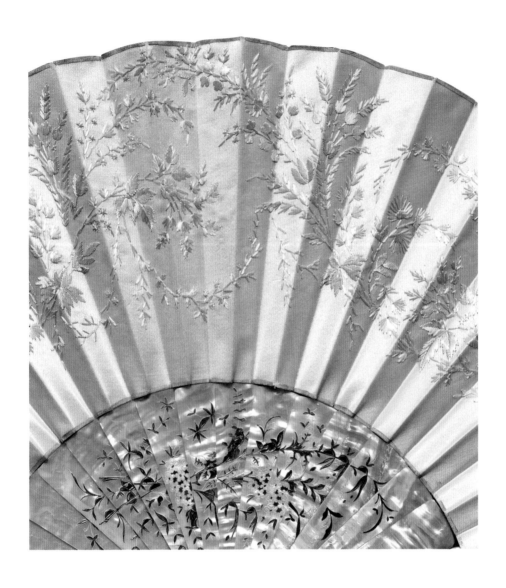

3-8. Embroidered silk and mother-of-pearl fan (detail), Europe, 19th century

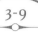

**3-9**

**PAINTED RED SILK AND
LACQUERED WOOD FAN**
Europe, early 20th century

The leaf painted front with
two birds and butterflies; the
back undecorated, the monture
lacquered red, 28.5 x 52 cm

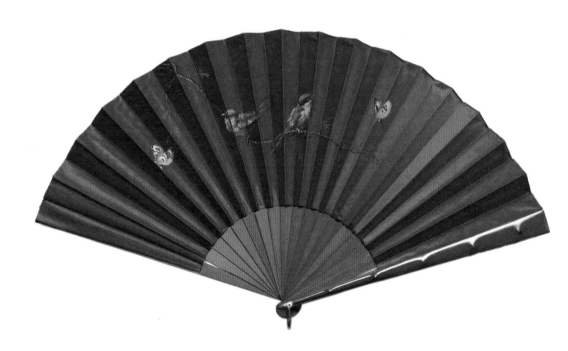

This brilliant red silk fan has wooden sticks and guards which are lacquered also in red in a style similar to Chinese lacquer. The centre of the fan leaf realistically depicts a pair of blue finches sitting on a branch, with two butterflies flying on either side, serving to enhance a sense of liveliness. The guards are decorated at regular intervals with protrusions that can be felt by the hand when gripped. In nineteenth-century Europe light and elegant textiles were widely used to make clothing; this trend was mirrored in fan-making, which used luxurious silk, lace and gauze, silk being the most predominant.

Silk is a fibre made from threads drawn from silkworm cocoons and is estimated to have first been made in China 8,500 years ago. This rare Eastern commodity (its production method was not known in Europe until much later) was imported by the Silk Road trade routes. Silk was first produced in Italy in the eleventh century and was then introduced to France and eventually to the rest of Europe. With the advent of the Industrial Revolution in the mid-eighteenth century, many innovative technologies were applied to silk making; different textures and lustres could be created depending on the weaving methods and materials used. Silk types with a soft texture, elegant lustre and luxurious patterning were selected for fan production. In terms of decoration, simple colours and embroidery were added, so as not to detract from the material's unique characteristics.

3-9. Painted red silk and lacquered wood fan (detail), Europe, early 20th century

3-10. Painted silk and ivory fan, Europe (detail), late 19th century

3-10

PAINTED SILK AND IVORY FAN
Europe, late 19th century

Painted floral sprays with
gouache on ivory-yellow
silk, 28.5 x 51 cm

The sticks and guards of this fan are made of ivory and its leaf is made of creamy-white silk. It is decorated all over with pink roses and blue wildflowers, with no distinction between its leaf and monture, thus enhancing its elegance. Flowers became a common subject for fan leaves some time in the seventeenth century, but they were used as decoration for the back only, since the most popular themes for the front of fan leaves were scenes from mythology, history and the Bible. However, in the mid-to-late nineteenth century flowers emerged as a primary focus for the frontside of fan leaves. This reflected the diversification of fan owners' tastes, the trend towards realism in paintings and the new fashion trends in clothing and ornaments. After the nineteenth century, further changes emerged: fans became larger in size, while the colours and structures became simplified. At the same time, there was more emphasis on utilising the specific characteristics of each material in the fan's design.

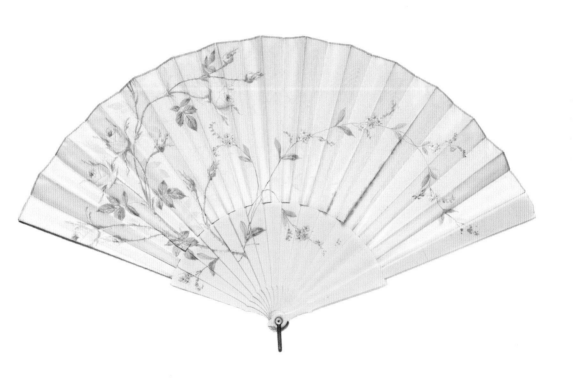

**3-II**

LACE AND
TORTOISESHELL FAN
France, mid-19th century

Black lace backed with white silk,
the principal guard applied with
a silver monogram, 26.5 x 48 cm

The sticks and guards of this fan are made of tortoiseshell and its leaf is made from silk and lace. Lace has been used as a material in fan-making since the eighteenth century and it is suitable both as a predominant material, for its aesthetic qualities, as well as a complementary material due to its transparency. With the development of lace-making technology from the mid-nineteenth century, lace fans with colourful floral patterns, such as this one, became popular. On the guard, the fan owner's initials "A" and "C" are monogrammed, showing that the fan was custom-made.

A monogram is a design consisting of two or more alphabetic letters combined or interlaced, commonly someone's initials, used as a personal signature or trademark. With the advent of printed posters in the early nineteenth century, typeface design became specialised and printing companies employed people to work on creating strikingly decorative designs. Font designs inspired by natural objects like plant stems and vines, such as the monogram on this fan, were popular.

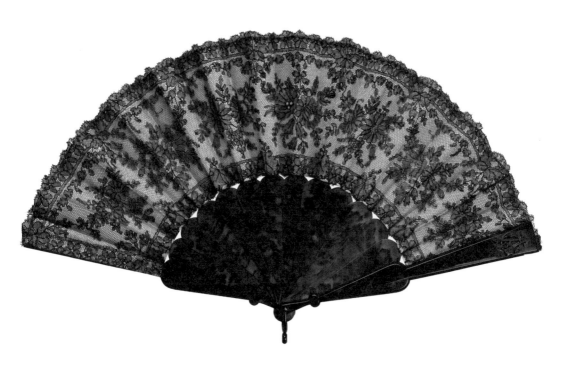

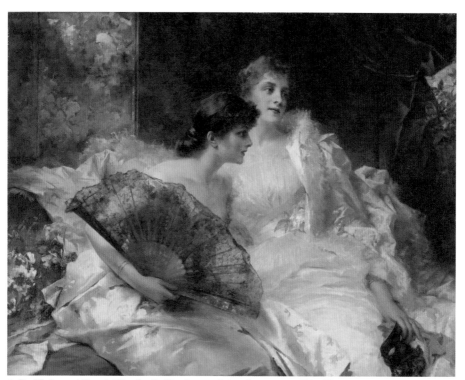

▲ Fig 27. Conrad Kiesel, *After the Ball*,* unknown date, oil on canvas, 75 × 95 cm

---

* The painting shows a woman holding a lace fan.

◀ 3-11. Lace and tortoiseshell fan (detail), France, mid-19th century

▶ 3-12. Lace-trimmed painted silk gauze and mother-of-pearl fan (detail), Europe,
late 19th century

3-12

**LACE-TRIMMED PAINTED SILK GAUZE AND MOTHER-OF-PEARL FAN**
Europe, late 19th century

Painted in gold and silver with butterflies and flowering vines, silver-inlaid monture, the guard applied with gold-coloured monogram, 35 x 62.5 cm

This fan's leaf is made of silk gauze and painted with gouache, while its edges are decorated with floral lace. The fan sticks are made of mother-of-pearl, decorated with silver inlay featuring a pattern of plants. On the guard, a gold-painted monogram with the initials "M" and "L" is attached, indicating that this fan was custom-made. Floral vines and butterflies are painted in gold on the leaf, harmonising with the floral patterns in lace, which elegantly enhances the fan's splendour. In addition, there is a tassel in the same colour as the leaf.

The silk gauze used for the leaf is a type of silk – chiffon – which is woven from silk thread and is characterised by its light weight. Due to silk gauze's delicate and soft texture, ease of handling and excellent colour retention from dyeing and painting, it was one of the most favoured materials for fan leaves in the late nineteenth century.

LACE-TRIMMED PAINTED
SILK GAUZE AND MOTHER-
OF-PEARL FAN
Europe, late 19th century

Fairy and floral sledge painting,
black lace trim, elaborately carved
monture decorated in polychrome,
gold and silver colour, 26.5 x 50 cm

Over the silk gauze leaf of this fan is a cartouche frame in Rococo style made of black lace. The sticks and guards are made of mother-of-pearl. The painting inside the cartouche frame depicts a fairy riding a sledge made of flowers drawn by two cherubs. Around the figures red, brown and blue butterflies are painted. The surrounding black lace gives the painting a dreamlike feel and, like a picture frame, makes the painting stand out. The delicate and dense pattern of the lace is an assortment of plant motifs, which appear to be influenced by Art Nouveau. The mother-of-pearl sticks and guards are elaborately carved with flower and plant shapes in gold and silver. The repetitive framed floral patterns on the sticks further enhance the fan's elegance.

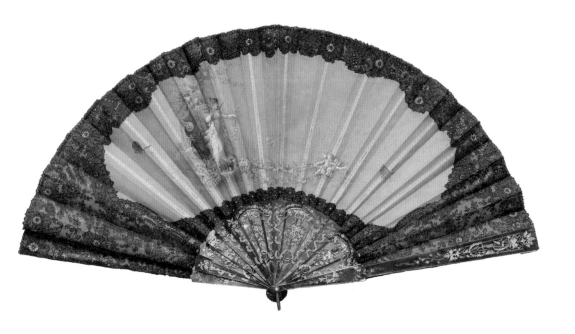

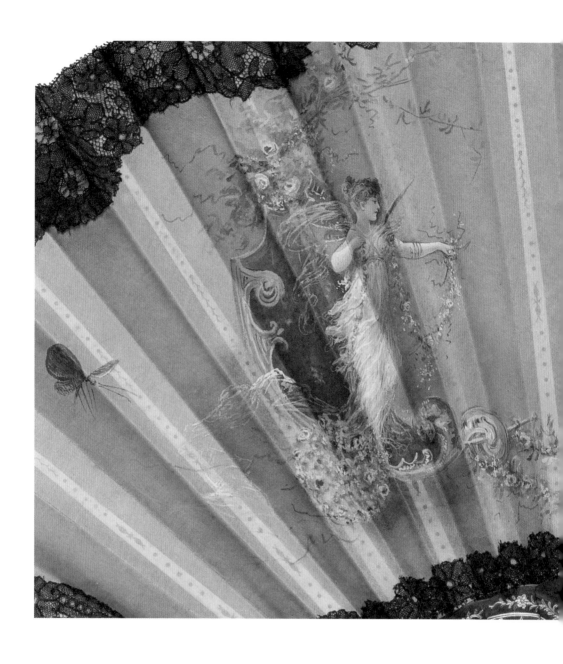

3-13. Lace-trimmed painted silk gauze and mother-of-pearl fan (detail), Europe, late 19th century

## 3-14

SPANGLED SILK AND BLOND
TORTOISESHELL FAN
Probably Germany,
early 19th century

Decorated with figures
representing the four seasons,
piqué monture, 21.5 x 37.5 cm

This fan's leaf is decorated in spangles on black silk and the sticks and guards are made of blond tortoiseshell. The leaf depicts angels in four different scenes, each representing a season and separated by a golden pillar: one holding up a floral wreath, another carrying grains and a sickle, the third raising a wine glass while holding a baton and the last angel tending to a fire. The faces of the angels are made from paper which has been delicately painted, cut out and then attached to the leaf. Spangles are thin pieces of metal or synthetic materials which can be coloured and made into various shapes – round, oval, square, floral. Due to their glossy appearance and light-reflecting properties, they were popular in the eighteenth and nineteenth centuries for decorating clothes, crafts and ornaments.

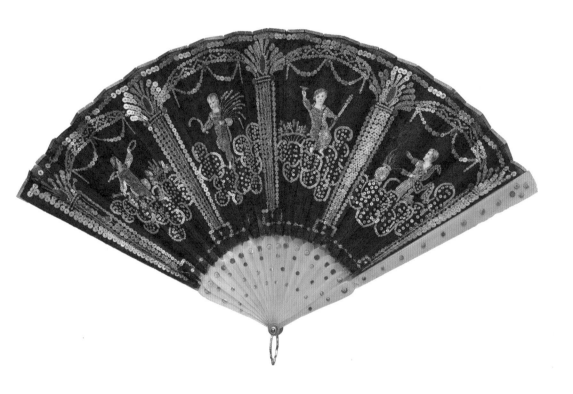

## 3-15

### SPANGLED BLACK LACE
### AND EBONISED WOOD FAN
Europe, late 19th century

Black lace and silk gauze
decorated with black
spangles, 19 x 34.5 cm

The wooden sticks and guards of this fan are ebonised and carved with plant shapes. The fan leaf is made of silk gauze with black lace layered on top. Underneath the black lace, black gauze is partially attached to emphasise the fan's shape. The entire fan leaf is elaborately decorated with round, petal and leaf-shaped black spangles. Despite the large number of spangles used, the fan remains sober in look due to their dark colour. Black fans were mainly used at funerals and memorials and were called "mourning fans".

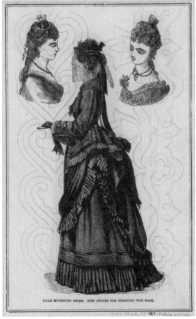

▲ Fig 28. "Half-mourning Dress: New Styles for Dressing the Hair",* print, 23 x 14 cm, *Peterson's Magazine*, March 1873, The New York Public Library, New York

* A print published in an illustrated fashion magazine from the 19th century. It depicts women's half-mourning attire, intended for the period after the initial deep mourning. Along with the dress, hat, veil and gloves, a hairstyle and fan are also specified.

## POLYCHROME SANDALWOOD BRISÉ PUZZLE FAN
### Europe, late 18th century

Decorated with an oval reserve depicting a "Moment musicale" flanked by two smaller reserves portraying mythological figures obverse and reverse, 22 x 39 cm

This brisé fan is made of sandalwood, which is also used to make perfume when extracted as an oil. A partial monture is delicately carved with geometric shapes and the rest is decorated with plant patterns and scroll shapes. Unlike typical folding fans, this fan can be opened from the left or right for both obverse and reverse sides. Each fan stick is divided in half vertically and painted with two different illustrations. Consequently, when the fan is opened from the right, the illustrations painted on the left half of the fan sticks make one scene. A different scene appears when the fan is opened from the left. The reverse side is also composed in this way. This arrangement, whereby there are two main scenes and two hidden ones, makes the fan quite unique. Such a playful invention provided entertainment over and above the fan's use as a fashion accessory.

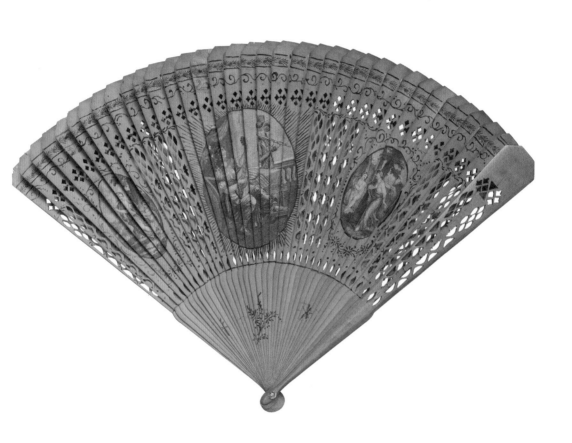

Obverse left *

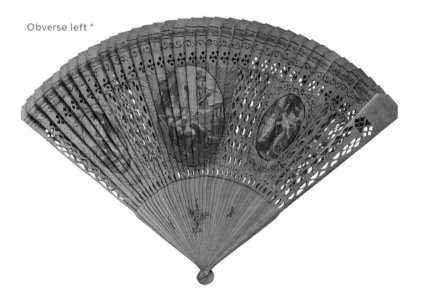

Obverse right **

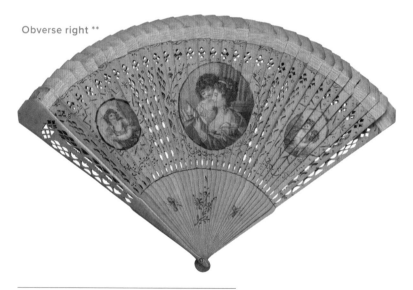

* When the obverse side is opened to the left, there are three oval reserves. The central image is of a seated woman playing the lute and a standing man playing the flute. The two smaller images on either side each contain an illustration of a woman and a child who appear to be characters from Greek or Roman mythology.
** When the obverse side is opened to the right, there are also three oval reserves. The central image shows two women reading sheet music. The side image on the left shows a woman with a mask while the image on the right portrays a woman holding a bunch of grapes.

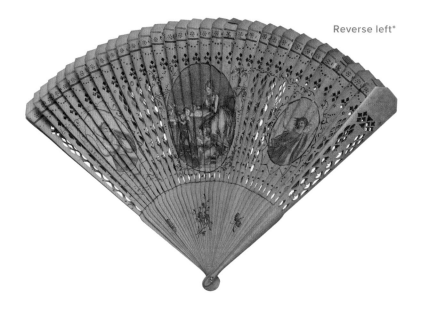

Reverse left*

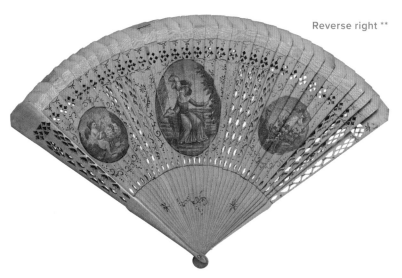

Reverse right **

* When the reverse side is opened to the left, the central reserve shows a woman embroidering at a table while two children play with thread. The right side depicts a woman dancing, while the woman shown on the left side is playing a harp.

** When it is opened to the right, there are three oval reserves in grey tones. The central image depicts a woman riding a lamb while holding a fan. The image on the left is of Cupid playing with a lamb and the right image shows Cupid playing with a dog.

**3-17**

**APPLIQUÉD WHITE SILK
GAUZE AND CELLULOID FAN**
Europe, probably 20th century

The shell-form mount appliquéd
with two silk roses, 31 x 40 cm

This fan has a leaf made of sheer silk gauze and a monture made of celluloid. Two silk roses are appliquéd on the leaf. The term "appliqué" originates from the Latin word *applicō*, which means "to put on", and it refers to sewing pieces of fabric of different patterns and shapes onto a larger background fabric. While this technique can be used in other arts and crafts, it is mainly used for textile decoration. At the beginning of the twentieth century, fan-makers experimented with fan shapes and materials, seeking new styles which would fulfil both durability and aesthetic needs. The imitation tortoiseshell used for the monture of this fan is indicative of the experimental spirit of the time. The guards of the fan are shorter than the sticks which gives it a shell shape, a popular form for fans in the early twentieth century.

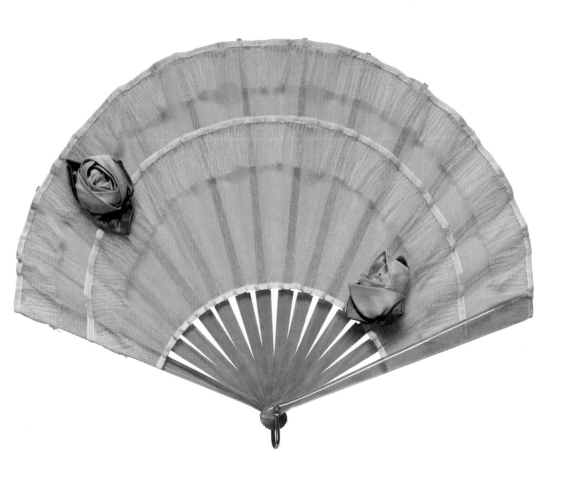

3-17. Appliqué white silk gauze and celluloid fan, Europe (detail), probably 20th century

▲ Fig 29. An appliqué on a dress - Madame Paquin, *"Boissy" Evening Gown*, Spring/Summer 1912, Kunstgewerbemuseum, Staatliche Museen zu Berlin, Berlin

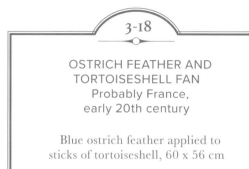

The main materials used in this fan are dyed ostrich feather and tortoiseshell. Having once been popular, the interest in feather fans decreased after the sixteenth century due to the growing dominance of folding fans. However, they reappeared in the late nineteenth century and by the 1920s feather fans dyed in various colours to match clothing had become an important fashion accessory. In the 1930s popular fan styles included one to three feathers fixed to the handle.

At first it was male ostrich feathers that were used for fans because of their vivid black and white colour. Later on female ostrich feathers, which are mostly brown, also started to be used. Both male and female ostrich feathers are easy to dye and to shape. Traditionally the ostrich feathers used were from wild ostriches. However, by the mid-nineteenth century, due to the high demand for feather products, ranging from ladies' hats to military headwear, wild ostriches had been brought to the verge of extinction and the supply of their feathers dwindled. It was through the establishment of ostrich farms in South Africa in 1865 that it became possible to meet the demand for feather products, including feather fans.

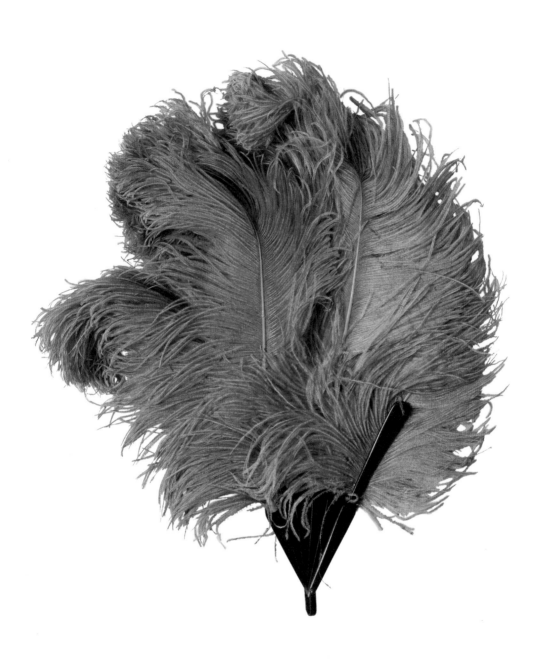

## PORCELAIN-HANDLED OSTRICH FEATHER FAN
### France, early 20th century

Comprised of a single plume mounted
in a rounded cylindrical handle of
Sèvres-type porcelain reserved from
a cobalt blue ground enriched with
gold-coloured decoration, 60 x 35 cm

This fan is made up of a single, non-dyed white ostrich feather fixed onto a porcelain handle in cobalt blue, painted with the portrait of a woman in a gold frame. Sèvres porcelain refers to the high-quality porcelain made by the Sèvres Manufactory in Sèvres, France, which became popular in the mid-eighteenth century with the support of Louis XV and Madame de Pompadour. The sophisticated craftsmanship of their porcelain and the quality of the artwork reproduced on it, by such well-known painters as François Boucher, established Sèvres' highly regarded reputation, resulting in many artisans following their style. Today the Sèvres Manufactory is owned by the French government and continues to produce porcelain of the same high quality.

▲ Fig 30. Julius LeBlanc Stewart, *Portrait of Mrs. Francis Stanton Blake*, 1908, oil on canvas, 200 x 112.4 cm, Walters Art Museum, Baltimore

▲ Fig 31. James Tissot, *A Woman of Ambition/Political Woman*, 1883–1885, oil on canvas, 142.2 x 101.6 cm, Albright-Knox Art Gallery, Buffalo

## 3-20

### BLUE IRIDESCENT FEATHER AND TORTOISESHELL FAN
Europe, 19th century

Feather leaf in blue
luminous colours, tortoiseshell
sticks, 34 x 53 cm

This fan's leaf is made from blue iridescent feather and its sticks and guards are made of tortoiseshell. Feather fans are typically made from a whole feather, maintaining the feather's wide shape, but this one is constructed by cutting the feather into small pieces and piecing them together to form a leaf. This feathered leaf is characterised by its changes in colour, depending on the viewer's angle and the direction of light. There is a dark reddish-brown tassel attached to the fan; it is in harmony with the colour of the tortoiseshell sticks and guards and subtly adds to the elegance of the fan.

# List of Figures

Fig 20    Mary Cassatt, *In the Loge*, 1878, oil on canvas, 81.28 × 66.04 cm, Museum of Fine Arts, Boston, accessed from http://commons.wikimedia.org

Fig 21    Rudolph Ackermann, *Ball Dress*, 1825, fashion plate, hand-coloured engraving on paper, 27.94 × 21.59 cm, Los Angeles County Museum of Art, Los Angeles, accessed from http://commons.wikimedia.org

Fig 22    *La Mode Illustrée*, 1883, 34.9 x 23.9 cm, Eurus Collection. © Eurus Collection

Fig 23    Giuseppe De Nittis, *La Parfumerie Violet*, c. 1880, oil on canvas, 40.5 × 32.5cm, Musée Carnavalet, Histoire de Paris, Paris, accessed from http://commons.wikimedia.org

Fig 24    Plates illustrating fan-making from *Encyclopédie*, c. 1751–1766, by Denis Diderot, engraving on paper, Smithsonian Design Museum, New York, accessed from http://cprhw.tt/o/2CRQr/ and http://cprhw.tt/o/2CRQr/

Fig 25    John Dawson Watson, *An Elegant Woman with a Fan*, 1871, pencil and watercolour on paper, 45 × 35.5 cm, The Maas Gallery, London. © The Maas Gallery, London / Bridgeman Images

Fig 26    Anonymous, *Designs for Gothic Tracery*, c. 1805, pen and black ink, 26 × 42.3 cm, The Metropolitan Museum of Art, New York, accessed from http://commons.wikimedia.org

Fig 27    Conrad Kiesel, *After the Ball*, unknown date, oil on canvas, 75 × 95 cm, accessed from http://commons.wikimedia.org

Fig 28    "Half-mourning Dress: New Styles for Dressing the Hair", print, 23 × 14 cm, *Peterson's Magazine*, March 1873, The New York Public Library Digital Collections. © NYPL

Fig 29    Madame Paquin, *"Boissy" Evening Gown*, Spring/Summer 1912, Kunstgewerbemuseum, Staatliche Museen zu Berlin, Berlin. © bpk / Kunstgewerbemuseum, SMB / Stefan Klonk

Fig 30    Julius LeBlanc Stewart, *Portrait of Mrs. Francis Stanton Blake*, 1908, oil on canvas, 200 × 112.4 cm, Walters Art Museum, Baltimore, accessed from http://commons.wikimedia.org

Fig 31    James Tissot, *A Woman of Ambition/Political Woman*, 1883–1885, oil on canvas, 142.2 × 101.6 cm, Albright-Knox Art Gallery, Buffalo, accessed from http://commons.wikimedia.org

Fig 32    Anatomy of a Folding Fan, Eurus Collection. © Eurus Collection

Fig 33    The Language of the Fan, Eurus Collection. © Eurus Collection

# References

**Books and Journals**

Addison, Joseph. "No. 102 Wednesday 27 June 1711". *The Spectator, Vol. 1*, 1711, 427–29. https://doi.org/10.1093/oseo/instance.00045547.

Alexander, Hélène. *Alexandre: Fan-Maker to the Courts of Europe*. London: Fan Museum, 2012.

Alexander, Hélène. *The Fan Museum*. London: Third Millennium Information Ltd, 2001.

Alexander, Hélène. *Fans : Hélène Alexander*. Edited by Aileen Ribeiro. London: B. T. Batsford Ltd, 1984.

Armstrong, Nancy. *The Book of Fans*. New York: Mayflower Books, 1978.

Armstrong, Nancy. *A Collector's History of Fans*. New York: C.N. Potter, 1974.

Becker, Udo. *The Continuum Encyclopedia of Symbols*. New York: Continuum, 2005.

Beevers, David. *Chinese Whispers: Chinoiserie in Britain, 1650–1930*. Brighton, England: Royal Pavilion & Museums, 2008.

Ching, Francis D.K. *A Visual Dictionary of Architecture*. Hoboken, NJ: John Wiley & Sons, 2012.

Coffin, Sarah. *Rococo: The Continuing Curve, 1730–2008*. New York: Cooper-Hewitt, National Design Museum, 2008.

Cowen, Pamela. *A Fanfare for the Sun King: Unfolding Fans for Louis XIV*. London: Fan Museum in association with Third Millenium Information Ltd, 2003.

Daley, Jennifer and Mida Ingrid, eds. "The Victorian Age: A History of Dress, Textiles, and Accessories, 1819–1901". *The Journal of Dress History* 4, no. 1 (2020). https://dresshistorians.org/wp/wp-content/uploads/2020/04/JDH_Spring_2020.pdf.

Dandona, Jessica M. *Nature and the Nation in Fin-De-siècle France: the Art of Emile Gallé and the Ecole de Nancy*. London: Routledge, Taylor & Francis Group, 2017.

Davies, Hugh. "Fanology: Hand-Fans in the Prehistory of Mobile Devices": *Mobile Media & Communication* 7, no. 3 (2019): 303–21. https://doi.org/10.1177/2050157919846181.

Earhart, H. Byron. *Mount Fuji: Icon of Japan*. Columbia, SC: University of South Carolina Press, 2011.

Elisseeff, Vadime. *The Silk Roads: Highways of Culture and Commerce*. Paris: UNESCO Publications, 2000.

The Fan Museum. *Royal Fans: 5th March–7th July 2002*. London: Fan Museum, 2002.

Gardner, Helen and Fred S. Kleiner. *Gardner's Art through the Ages: A Global History*. Boston, MA: Cengage Learning, 2016.

Gardner, Helen, Christin J. Mamiya and Fred S. Kleiner. *Gardner's Art through the Ages*. Belmont, CA: Thomson/Wadsworth, 2005.

Heller-Greenman, Bernadine. "Moreau Le Jeune and the Monument Du Costume". *ATHANOR XX, Florida State University, Department of Art History* 20 (1 January 2002), 67–76.

Hiner, Susan. *Accessories to Modernity: Fashion and the Feminine in Nineteenth-Century France*. Philadelphia: University of Pennsylvania Press, 2010.

Hutt, Julia and Hélène Alexander. *Ogi: A History of the Japanese Fan*. London: Dauphin, 1992.

Hwajeong Museum. *Yu-leob-gwa dong-a-si-a bu-chae* [Fans from Europe and East Asia]. Seoul: The Hahn Cultural Foundation, 2002.

Jacobson, Dawn. *Chinoiserie*. London: Phaidon Press, 2007.

Kirkham, Pat, Susan Weber and John Alderman. *History of Design: Decorative Arts and Material Culture, 1400-2000*. New York: Bard Graduate Center: Decorative Arts, Design History, Material Culture, 2013.

Kleutghen, Kristina. "Imports and Imitations: The Taste for Japanese Lacquer in Eighteenth-Century China and France". *Journal for Early Modern Cultural Studies* 17, no. 2 (2017): 175–206. https://doi.org/10.1353/jem.2017.0013.

Koda, Harold and Andrew Bolton. *Dangerous Liaisons: Fashion and Furniture in the Eighteenth Century*. New York: Metropolitan Museum of Art, 2006.

Lane, Hannah. "'L'Orage des Passions': Expressing Emotion on the Eighteenth-Century French Single-Action Harp". *Cerae: An Australasian Journal of Medieval and Early Modern Studies* Volume 1 (2014): 75–89.

Lespinasse, René de. "Éventaillistes". In *Les Métiers et Corporations de la Ville de Paris : XIIIe-XVIIIe siècle*, Paris : Imprimerie nationale, 1892.

Levenson, Jay A. *Circa 1492: Art in the Age of Exploration*. Washington: National Gallery of Art, 1991.

"L'éventail Matières D'excellence". Musée de la Nacre et de la Tabletterie, August 2015. https://musee-nacre.fr/fr/presse/doc_download/63-

Macdonald, Helen. *Falcon*. London: Reaktion, 2016.

Major, Philip ed. *Sir John Denham (1614/15–1669) Reassessed: The State's Poet*. Routledge, 2019.

Marandel, Jean Patrice. *Europe in the Age of Enlightenment and Revolution*. New York: Metropolitan Museum of Art, 1987.

Milam, Jennifer Dawn. *Historical Dictionary of Rococo Art*. Lanham: The Scarecrow Press, Inc., 2011.

Moch, Leslie Page. *Moving Europeans: Migration in Western Europe since 1650*. Bloomington Ind: Indiana University Press, 2003.

"Notes Regarding Tortoiseshell, Mother-of-Pearl and Ivory". *FANA Journal*, Spring & Fall (2017): 23–29.

Porter, David. "Monstrous Beauty: Eighteenth-Century Fashion and the Aesthetics of the Chinese Taste". *Eighteenth-Century Studies* 35, no. 3 (2002): 395–411. https://doi.org/10.1353/ecs.2002.0031.

Roberts, Jane, Prudence Sutcliffe and Susan Mayor. *Unfolding Pictures: Fans in the Royal Collection*. London: Royal Collection, 2005.

Snodin, Michael and Nigel Llewellyn. *Baroque: Style in the Age of Magnificence 1620–1800*. London: V & A Publishing, 2009.

Tcherviakov, Alexandre F. *Fans, from the 18th to the Beginning of the 20th Century: Collection of the Palace of Ostankino in Moscow*. Bournemouth: Parkstone, 1998.

Tsang, Ka Bo. *More than Keeping Cool: Chinese Fans and Fan Painting*. Toronto: Royal Ontario Museum, 2002.

Verschuer, Charlotte von. *Across the Perilous Sea: Japanese Trade with China and Korea from the Seventh to the Sixteenth Centuries*. Ithaca, NY: Cornell University, 2006.

Volmert, Miriam. "Ruins to Take Away. Roman Grand Tour Fans and Eighteenth-Century Souvenir Culture". Chapter in *European Fans in the 17th and 18th Centuries: Images, Accessories, and Instruments of Gesture*, edited by Miriam Volmert and Danijela Bucher, 137–62. Berlin: De Gruyter, 2020.

Ward, Gerald W.R., ed. *The Grove Encyclopedia of Materials and Techniques in Art*. Oxford: Oxford University Press, 2008.

Webb, Marianne. *Lacquer: Technology and Conservation: A Comprehensive Guide to the Technology and Conservation of Asian and European Lacquer*. Oxford (England): Butterworth-Heinemann, 2007.

Yuqi, Zhou. *Bu-chae-ui un-chi* [Appreciating the Fan]. Translated by Seung Mi Park. Busan: Sanzini Books, 2005.

Zhang, Xiaoming. *Chinese Furniture*. Cambridge: Cambridge University Press, 2011.

**Websites**

"A Painting in the Palm of Your Hand: 18th-Century Painted Fans from the Wendy and Emery Reves Collection". Exhibition, Dallas Museum of Art. Dallas Museum of Art, June 2007. https://dma.org/painting-palm-your-hand-18th-century-painted-fans-wendy-and-emery-reves-collection.

"Andre-Charles Boulle (1642–1732)". Sotheby's, 30 October 2020. https://www.sothebys.com/en/articles/andre-charles-boulle-1642-1732.

"Fan Mount: The Cabbage Gatherers" by Camille Pissarro. The Metropolitan Museum of Art. Accessed 13 May 2021. https://www.metmuseum.org/art/collection/search/437315.

"Fan Mount: Edgar Degas Ballet Girls". The Metropolitan Museum of Art. Accessed 13 May 2021. https://www.metmuseum.org/art/collection/search/436142.

"Fanology or the Ladies Conversation Fan". Christie's. Accessed 12 May 2021. https://www.christies.com/en/lot/lot-3829284.

"France - Cabriolet Fan". Royal Collection Trust. Accessed 12 May 2021. https://www.rct.uk/collection/25380/cabriolet-fan.

"Francis Houghton, Autograph Fan". Royal Collection Trust. Accessed 19 May 2021. https://www.rct.uk/collection/25064/autograph-fan.

"Hand Screen". Victoria and Albert Museum: Explore the Collections. Accessed 23 May 2021. https://collections.vam.ac.uk/item/O372300/hand-screen-jennens-bettridge/hand-screen-jennens--bettridge/.

Meagher, Jennifer. "Orientalism in Nineteenth-Century Art". The Metropolitan Museum of Art. Accessed 20 May 2021. https://www.metmuseum.org/toah/hd/euor/hd_euor.htm.

"Mother-of-Pearl: A Tradition in Asian Lacquer". The Metropolitan Museum of Art. Accessed 27 May 2021. https://www.metmuseum.org/exhibitions/listings/2006/mother-of-pearl.

"Paul Gauguin Arearea (Joyfulness) II". The Museum of Fine Arts, Houston. Accessed 13 May 2021. https://emuseum.mfah.org/objects/4242/arearea-joyfulness-ii.

"Portrait of Louis XIV (Getty Museum)". The Getty Museum. Accessed 19 May 2021. https://www.getty.edu/art/collection/objects/547/after-hyacinthe-rigaud-portrait-of-louis-xiv-french-after-1701/.

Starp, Alexandra. "The Secret Language of Fans". Sotheby's, 16 July 2018. https://www.sothebys.com/en/articles/the-secret-language-of-fans.

"Study for the Triumph of Neptune and Amphitrite or the Birth of Venus (Getty Museum)". The Getty Museum. Accessed 24 May 2021. https://www.getty.edu/art/collection/objects/169/nicolas-poussin-study-for-the-triumph-of-neptune-and-amphitrite-french-about-1635/.

"The Encyclopédie". Victoria and Albert Museum. Accessed 24 May 2021. https://www.vam.ac.uk/articles/the-encyclopédie.

"The Influence of East Asian Lacquer on European Furniture". Victoria and Albert Museum. Accessed 17 May 2021. https://www.vam.ac.uk/articles/east-asian-lacquer-influence.

"Types of Fan". The Fan Circle International. Accessed 20 May 2021. https://www.fancircleinternational.org/collecting-fans/fan-glossary/types-of-fan/.

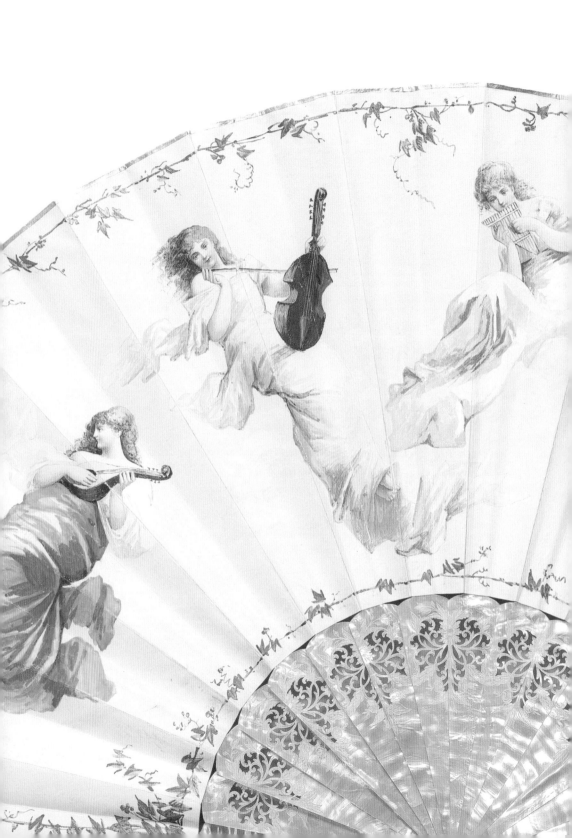

# Appendix

Timeline

Anatomy of a Folding Fan

Glossary

The Language of the Fan

List of Fans

About Eurus Collection

# Timeline

| European Art | French Monarchies and Republics | | British Monarchies | | European Decorative Arts |
|---|---|---|---|---|---|
| Baroque | (House of Bourbon) Henri IV | 1589 | | | |
| | Louis XIII | 1610 | | | |
| Rococo | Louis XIV | 1643 | | | |
| | Louis XV | 1715 | 1714 | George I (House of Hanover) | |
| | | | 1727 | George II | |
| | | | 1760 | George III | |
| Neoclassicism | Louis XVI | 1774 | | | |
| Romanticism | First Republic | 1792 | | | Georgian (1714–1830) |
| | Napolean I (First Empire) | 1804 | | | |
| | Louis XVIII | 1815 | | | |
| Realism | | | 1820 | George IV | |
| | Charles X | 1824 | | | |
| | Louis Philippe I | 1830 | | | |
| | | | 1837 | Queen Victoria | |
| | Second Republic | 1848 | | | |
| | Napolean III (Second Empire) | 1852 | | | Victorian (1830–1900) |
| | Third Republic | 1870 | | | |
| Impressionism | | | | | |
| Art Nouveau | | | 1901 | Edward VII (House of Saxe-Coburg and Gotha) | |
| | | | 1910 | George V (House of Windsor) | Edwardian (1901–1914) |
| Art Deco | | | 1936 | Edward VIII George VI | |
| | | | 1953 | Elizabeth II | |

# Anatomy of a Folding Fan

**Monture**
The solid structure which supports the fan leaf and is divided into fan sticks and fan guards. The monture is usually made of a solid material such as ivory, tortoiseshell, wood, horn or bone.

**Guards**
The two rods on the outer part of a fan. They are generally thicker than the fan sticks. When the fan is folded, the guards protect the fan sticks and fan leaf. Various decorations are applied to the guards.

**Sticks**
A part of the monture excluding guards. They are divided into the gorge and ribs.

**Gorge**
The area of the fan sticks situated below the fan leaf and above the head. Sometimes this part is carved or painted.

**Ribs**
The upper portion of the fan sticks which support the fan leaf. For a single-sided fan leaf, the ribs are exposed on the reverse side. If the fan leaf is double sided, the ribs are covered by the leaf.

**Leaf or Mount**
The part of a fan above the gorge. This part can be made of various materials such as vellum, paper, silk and lace. A leaf can be made with one or two layers.

**Pivot / Rivet**
The pin that is inserted to fix the fan sticks and guards together.

**Head**
The lowest part of the sticks where the pivot or rivet is located.

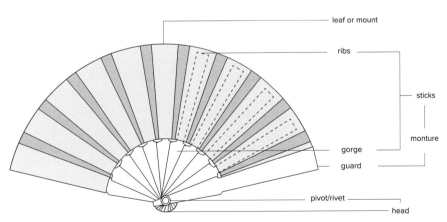

▲ Fig 32. Anatomy of a Folding Fan, Eurus Collection

# Glossary

**Types of fans**

**Battoir fan**
A type of fan with circle-shaped sticks resembling tennis racquets.

**Brisé fan**
A type of folding fan that is made of only sticks and guards.

**Cabriolet fan**
A fan made with two distinct leaves, in a shape similar to the wheels of a light horse-drawn carriage (a cabriolet).

**Cockade**
A fan which can be opened to a full circle. When unfolded, the rivet pin is located in the centre of the fan.

**Éventail**
French word for "fan".

**Flabellum**
A fan used for religious ceremonies. Its use dates back to ancient Egypt.

**Fixed fan**
A fan with a round- or square-shaped screen, with a handle attached.

**Folding fan**
A fan with a pleated leaf that can be folded and unfolded. It is called *Juil Buche* (쥘부채) in Korea, meaning a "hand grip fan", due to its portable nature.

**Fontange fan**
A fan named after the fontange headdress which was popular during the late 17th and early 18th century. Like the headdress, the fan leaf is rounded with the centre of the leaf higher than the guards.

**Hand-screen**
A rigid fixed fan with a handle, used to protect the face from sunlight or heat. It is usually round or square.

### Baroque style

A style that flourished in art, architecture and music in Europe from the late 16th to mid-18th century. "Baroque" comes from the Portuguese phrase *pérola barroca*, which means "irregular pearl". Baroque style is an extension of and a reaction against the Renaissance period of the 14th to 16th century, which emphasised harmonious aesthetics. Baroque style is characterised by its dramatic, dynamic, colourful and exaggerated forms.

### Chinoiserie

The term originates from the French word *chinois* and refers to a Western style of decorative arts, design, textiles and other crafts that combines Chinese style with 18th-century Rococo design.

### "Fête galante"

A term used to describe a type of painting which first came to prominence with Antoine Watteau. They show groups of elegantly attired men and women, most often placed in a parkland setting and engaged in decorously amorous play. Influenced by the 16th-century Venetian paintings of outdoor scenes, it represents the life of the European nobility in a dramatic way.

### "Moment pastorelle"

A reference to a poetic scene of simple and peaceful rural life.

### Louis XIII style

A popular style in art, architecture and the decorative arts during the reign of Louis XIII (1610–1643). It is a mixture of Italian influences introduced by Louis XIII's mother, Marie de' Medici, with Flemish and Spanish styles. Works of art and craft reflecting Louis XIII's aesthetic tastes were also produced in subsequent centuries.

### Louis XIV style

A popular style in architecture, art and the decorative arts during the reign of Louis XIV (1643–1715). It emphasises grandeur, order and symmetry, representing the absolute power of Louis XIV, the Sun King. After the 18th century a style reproducing the aesthetic taste of Louis XIV re-emerged.

### Louis XV style

A popular style in the arts during the reign of Louis XV. During the earlier part of his reign (1710–1730), it was also known as the Régence style which is lighter in form than the Louis XIV style. In the middle period of his reign (1730–1750), under the influence of Madame de Pompadour, the King's chief mistress, the style became more dynamic by embracing the Rococo style. During the latter phase of his reign (1750–1774), it became more orderly. The Louis XV style is heavily associated with the Rococo style.

### Rococo style

A popular style in art, architecture and music in Europe during the 17th and 18th century. The term "Rococo" is derived from the French word *rocaille* which refers to a decoration style employing pebbles or shells, typically used in fountains or grottoes. It is characterised by atypical shapes and espouses asymmetrical and playful aesthetics.

### Rococo Revival style

A style which predominantly influenced the decorative arts. It emerged during the reign of Napoleon III, Second French Empire (1852–1870), and was popular among the bourgeoisie. It is characterised by a mixture of royal and aristocratic art styles that existed prior to the 19th century and was particularly influenced by the Rococo style, which was popular during the Louis XV period.

## Materials and techniques

### À l'Anglaise
A single leaf application where the ribs are visible on the reverse side. Sometimes the ribs on the reverse side, or even the entire reverse fan leaf, are painted.

### Appliqué
A craft term which refers to the technique of attaching or sewing different materials onto a base material. Various materials such as paper, fabric, leather, wood board, metal plate and glass can be used.

### Bone
Animal bones, horns and teeth, of which cow bone is most common, used as a craft material. Bone carvings and ornaments have been discovered among prehistoric relics and have been used in craft works around the world. Due to its relatively low price, it was used as a substitute for ivory.

### Cabochon cut
A type of cut for gemstones, it refers to a technique that polishes the surface of gemstones into spherical (convex) shapes.

### Cameo
Cameo refers to a technique of embossing translucent or opaque gemstones, mother-of-pearl and glass. It is characterised by layered carving and is often used in ceramics and jewellery. The cameo technique is ancient, its usage dating back as far as 5th-century BC Greece. In the mid- to late 19th century, it became popular with the general public. Émile Gallé, a French artist, is known for his frequent employment of the technique in his glassworks.

### Cartouche
A decorative element found both in Rococo architecture and in interior decoration. Representing a scroll with one or both ends curled up, it was used in paintings and crafts as a frame decoration. It was also used in book and letter illustrations.

### Celluloid
A type of plastic made of nitrocellulose. It was invented by John Wesley Hyatt in the USA in 1869. It is widely used for fan sticks because it is inexpensive and easy to process.

### Découpage
A craft technique which derives its name from the French word for "cut out". The technique involves attaching coloured paper cut-outs onto an object.

### Ebonised
The term refers to the application of a black coating of paint or stain so as to achieve the dark and glossy appearance of the lacquer technique.

### Gilt
A type of metal decoration technique in which gold powder or a thin gold leaf is fixed onto a surface.

### Gouache
An opaque, water-based paint using water-soluble gum arabic. It can be used in combination with watercolour paints and is effective for producing opaque as well as translucent textures.

### Horn
Horn refers to the horns of cows, sheep and goats. In craft works, cow horns are primarily used. Although horn has been used as a craft material since ancient times, due to its scarcity and difficult method of processing it is considered to be a rare material. The processing involves applying heat and pressure to the horns in order to manipulate their shape.

### Inlay
A type of craft and sculpting technique which involves engraving a pattern on a surface and then filling it with other materials. It creates contrasting effects between the colours of the different materials.

### Ivory
A material made from animal tusks (typically elephants). Due to its colour and glossiness, ivory has been treated as a precious craft material since ancient times. With several decades of global efforts to ban the reckless capture of elephants, crafts made of ivory have become a thing of the past.

### Lithography
A printing process invented by the German playwright Alois Senefelder at the end of the 18th century. The process uses a reaction between water and oil, and it was used in arts and crafts throughout the 19th century.

**Mother-of-pearl**
The term refers to processed seashells used as a material for craft and jewellery making. In the East, it was frequently used as a material for *Najeon* (螺鈿), a lacquer technique. In particular, in Tang dynasty China, mother-of-pearl was used to produce high-quality craft works.

**Organza**
A sheer yet stiff fabric made from silk.

**Papier découpé**
A paper craft technique, believed to have originated in China, involving cutting shapes of people, objects and various patterns from a single piece of paper.

**Papier-mâché**
Refers to mashed paper bound with an adhesive. After forming and hardening, the surface is finished with lacquer or varnish.

**Pierced, Openwork**
A technique that creates decorative patterns by piercing holes in a hard material.

**Piqué**
A technique of inlaying decorative shapes using small pieces of gold, silver or other precious metals onto a main material such as tortoiseshell or ivory.

**Porcelaine de Sèvres**
A reference to the high-quality porcelain made by the Sèvres Manufactory in Sèvres, France. It became popular in the mid-18th century with the support of Louis XV and Madame de Pompadour.

**Relief**
A technique of sculpting a three-dimensional shape on a plane using the same material. Since one side is flat, it is often used to decorate walls of architectural structures.

**Scroll**
A decorative spiral pattern primarily used on stone and wood.

**Silk**
A sheer and light natural fabric. It is difficult to estimate its initial production date, but the country of origin was China. Silk was a rare and expensive material that was used as a currency. It influenced the naming of the "Silk Road" as it was one of the most important trade items between the East and the West.

**Silk gauze**
A type of silk fabric that is similar to chiffon but lighter in weight.

**Spangle**
A thin piece of metal or synthetic material used for decorating clothes, crafts and ornaments due to its light reflecting properties and shimmery appearance. It can be coloured and its shape can vary – round, oval, square and floral shapes are the most common.

**Tassel**
A decoration made from several strands of thread.

**Tortoiseshell**
A term that refers to the back shell of a tortoise or turtle. Semi-transparent and mottled with unusual patterns, it was regarded as a valuable material for crafts as it could be heated and made flexible. Tortoiseshell is said to have been imported from Egypt to Europe via Rome. André Charles Boulle (1642–1732), a French furniture maker of the 17th century under Louis XIV, is known to have frequently used this material. Tortoiseshell became popular from the early 19th to the 20th century and was used as a material for women's make-up tools, combs, hair ornaments and special fans.

**Vellum**
A writing material made of the skin of such animals as calves, sheep and goats. It is also used to make fan leaves and other craft works. Sometimes vellum is used interchangeably with the term "parchment", which is a broader term for untanned animal skins.

**Vernis Martin**
A varnishing technique which was primarily used in France in the 18th century. It has a decorative effect similar to that of Eastern lacquer and has been widely used for crafts and interior decoration. It is named after Robert Martin (1706–1765) and his brothers.

# The Language of the Fan*

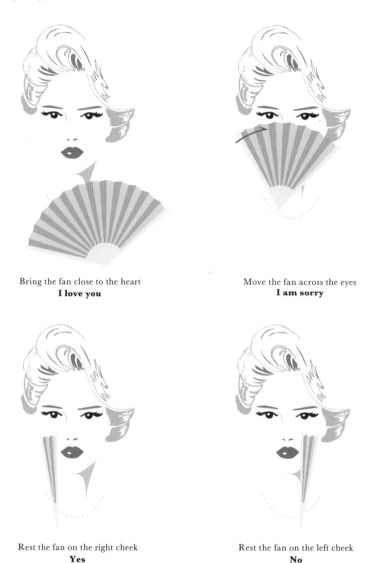

Bring the fan close to the heart
**I love you**

Move the fan across the eyes
**I am sorry**

Rest the fan on the right cheek
**Yes**

Rest the fan on the left cheek
**No**

▲ Fig 33. The Language of the Fan, Eurus Collection

* Illustrations produced based on "The Language of the Fan" leaflet published by Duvelleroy in the 19th century.

Press lips with the
half-opened fan
**You may kiss me**

Place the closed fan next
to the right eye
**When can I see you?**

Twirl the fan with the right hand
**I love another**

Twirl the fan with the left hand
**We are being watched**

Drop the fan = **We will be friends**
Slowly close the opened fan =
**I promise to marry you**
Fanning slowly = **I am married**
Fanning quickly = **I am engaged**

Open the fan wide = **Wait for me**
Touch the tip of the fan =
**I wish to speak with you**
Hold the opened fan with the left
hand = **Come and talk to me**

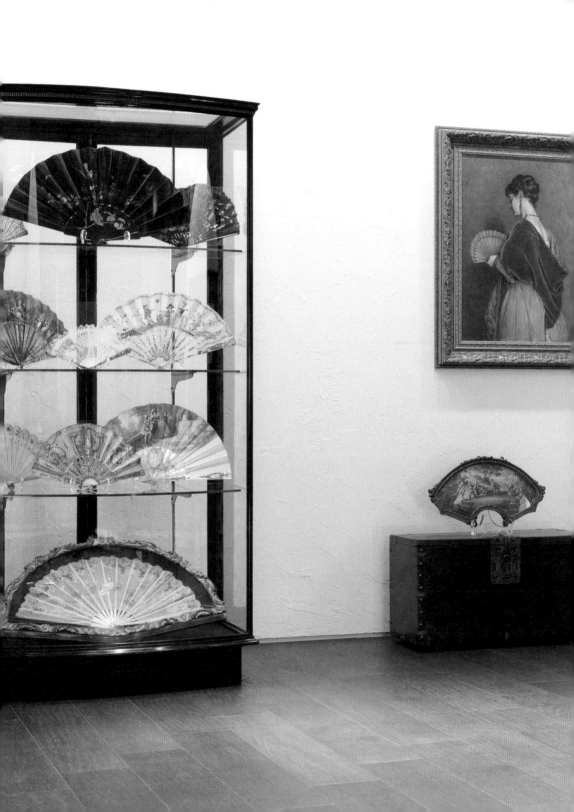

# List of Fans

| No. | | Title | Date and Place | Size |
|-----|--|-------|----------------|------|
| 1-1 | | Vernis Martin Lacquered Ivory Brisé Fan | Early 18th century, France | 19 x 34.5 cm |
| 1-2 | | Louis XV-style Painted Vellum and Ivory Fan | Mid-18th century, France | 24.5 x 44.5 cm |
| 1-3 | | Louis XV-style Painted Paper and Ivory Fan | c. 1870, France | 21 x 39.5 cm |
| 1-4 | | Louis XVI-style Painted Vellum and Mother-of-Pearl Fan | Late 18th century, France | 22 x 39.5 cm |
| 1-5 | | Hand-Coloured Lithographed Paper and Ivory Fan | Late 19th century, probably France | 27.2 x 49.3 cm |
| 1-6 | | Hand-Coloured Lithographed Paper and Ebonised Wood Fan | Mid-19th century, Europe | 27.2 x 51 cm |
| 1-7 | | Hand-Coloured Lithographed Paper and Papier-Mâché Fan | Mid-19th century, Europe | 27 x 52 cm |
| 1-8 | | Painted Vellum and Mother-of-Pearl Fan | Mid-18th century, France | 28 x 52 cm |

| No. | | Title | Date and Place | Size |
|-----|---|-------|----------------|------|
| 1-9 | | Hand-Coloured Lithographed Paper and Cameo-Carved Mother-of-Pearl Fan | Mid-19th century, Europe | 27 x 53 cm |
| 1-10 | | Painted Vellum and Ivory Fan | Mid-18th century, Europe | 27 x 47 cm |
| 1-11 | | Painted Vellum and Mother-of-Pearl Cabriolet Fan | 19th century, Europe | 21.5 x 39.5 cm |
| 1-12 | | Hand-Coloured Lithographed Vellum and Ivory Commemorative Fan | c. 1846, probably France | 27.5 x 53 cm |
| 1-13 | | Hand-Coloured Lithographed Paper and Mother-of-Pearl Fan | Mid-19th century, Europe | 26.5 x 51 cm |
| 1-14 | | Louis XIII-style Papier-Mâché Fixed Fan | Mid-19th century, Europe | 38 x 25 cm |
| 1-15 | | Louis XIII-style Painted Fabric and Ivory Fan | Late 19th century, Europe | 23 x 41 cm |
| 1-16 | | Louis XIV-style Hand-Coloured Lithographed Paper and Ivory Fan | Late 19th century, Europe | 27 x 50 cm |

| No. | | Title | Date and Place | Size |
|-----|---|-------|----------------|------|
| 1-17 | | Painted Faux Ivory Brisé Fan | Late 19th century, Europe | 14 x 24 cm |
| 1-18 | | Painted Black Silk Gauze and Tortoiseshell Fan | Late 19th century, England | 39 x 74 cm |
| 1-19 | | Painted Vellum and Mother-of-Pearl Fan | Late 19th century, Europe | 24.5 x 46 cm |
| 1-20 | | Hand-Coloured Lithographed Paper and Mother-of-Pearl Fan | 19th century, probably France | 14.5 x 45.5 cm |
| 1-21 | | Painted Organza and Faux Ivory Fan | Early 20th century, Europe | 26 x 49 cm |
| 1-22 | | Painted Fabric and Celluloid Fan | 19th century, Europe | 28 x 52.5 cm |
| 1-23 | | Jenny Lind Fan | Late 19th century, Europe | 17.6 x 32.3 cm |
| 1-24 | | Jenny Lind Fan | Late 19th century, Europe | 27.7 x 51 cm |

| No. | | Title | Date and Place | Size |
|---|---|---|---|---|
| 1-25 | | Painted Vellum and Mother-of-Pearl Fan | Late 19th century, Europe | 29 x 53 cm |
| 1-26 | | Painted Vellum and Mother-of-Pearl Fan | Late 19th century, Europe | 28.5 x 54 cm |
| 1-27 | | Painted Paper and Mother-of-Pearl Fan | 1888, France | 32 x 70 cm |
| 2-1 | | Painted Vellum and Ivory Fan | 18th century, Europe | 27 x 40 cm |
| 2-2 | | Painted Vellum and Ivory Fan | 18th century, probably Italy | 24 x 40.3 cm |
| 2-3 | | Polychrome Ivory Brisé Fan | Early 18th century, Europe | 21.5 x 30.5 cm |
| 2-4 | | Painted Vellum and Ivory Fan | 18th century, probably Italy | 27 x 49.5 cm |
| 2-5 | | Chinoiserie Painted Paper and Wood Fan | Mid-18th century, Europe | 29 x 48 cm |

| No. | | Title | Date and Place | Size |
|-----|---|-------|----------------|------|
| 2-6 | | Chinoiserie Painted Paper and Ivory Fan | Early 18th century, Europe | 26 x 38.5 cm |
| 2-7 | | Chinoiserie Appliquéd Painted Silk and Ivory Fan | Mid-18th century, Europe | 24 x 50 cm |
| 2-8 | | Chinoiserie Painted Papier-Mâché and Wood Fixed Fan | Mid-19th century, Europe | 40 x 26 cm |
| 2-9 | | Papier-Mâché and Ivory Fixed Fan | Mid-19th century, Europe | 40 x 24.5 cm |
| 2-10 | | Hand-Coloured Lithographed Paper and Bone Fan | Late 19th century, Europe | 27.2 x 51.2 cm |
| 2-11 | | Polychrome Tortoiseshell Brisé Fan | 19th century, Europe | 15 x 27 cm |
| 2-12 | | Painted Silk and Horn Fan | Early 20th century, Europe | 24.5 x 45 cm |
| 2-13 | | Painted Black Silk Gauze and Faux Tortoiseshell Fan | 1905, France | 35.5 x 44 cm |

| No. | | Title | Date and Place | Size |
|---|---|---|---|---|
| 2-14 | | Painted Silk and Wood Fan | Probably 1870s, Europe | 38 x 65.5 cm |
| 2-15 | | Ivory Cockade Fan | Early 19th century, Europe | 23 x 17 cm |
| 2-16 | | "Golden Links Calendar" Fan | 1892, Germany | 25.3 x 47 cm |
| 2-17 | | Hand-Coloured Lithographed Paper and Wood Fan advertising the perfume "Azurea" | Early 20th century, France | 25 x 45 cm |
| 2-18 | | Lithographed Paper Commemorative Fan | c. 1848, France | 22 x 40 cm |
| 2-19 | | Polychrome Wood Brisé Souvenir Fan | Mid-19th century, Switzerland | 23.5 x 41 cm |
| 3-1 | | Ivory Brisé Fan | 1870s, Germany | 41 x 23 cm |
| 3-2 | | Ivory Brisé Fan | 1830, England | 15.5 x 26 cm |

| No. | | Title | Date and Place | Size |
|-----|---|-------|----------------|------|
| 3-3 | | Tortoiseshell Brisé Fan | 19th century, Europe | 21.5 x 38 cm |
| 3-4 | | Polychrome Horn Brisé Fan | c. 1820–1830, France | 19 x 28 cm |
| 3-5 | | Wood Brisé Fan | Probably late 19th century, Europe | 23.5 x 41 cm |
| 3-6 | | Spangled and Embroidered Silk and Bone Fan | 19th century, Europe | 21.5 x 37.5 cm |
| 3-7 | | Painted Red Silk and Mother-of-Pearl Fan | 19th century, Europe | 21.5 x 40 cm |
| 3-8 | | Embroidered Silk and Mother-of-Pearl Fan | 19th century, Europe | 27 x 49.5 cm |
| 3-9 | | Painted Red Silk and Lacquered Wood Fan | Early 20th century, Europe | 28.5 x 52 cm |
| 3-10 | | Painted Silk and Ivory Fan | Late 19th century, Europe | 28.5 x 51 cm |
| 3-11 | | Lace and Tortoiseshell Fan | Mid-19th century, France | 26.5 x 48 cm |

| No. | | Title | Date and Place | Size |
|-----|---|-------|----------------|------|
| 3-12 | | Lace-Trimmed Painted Silk Gauze and Mother-of-Pearl Fan | Late 19th century, Europe | 35 x 62.5 cm |
| 3-13 | | Lace-Trimmed Painted Silk Gauze and Mother-of-Pearl Fan | Late 19th century, Europe | 26.5 x 50 cm |
| 3-14 | | Spangled Silk and Blond Tortoiseshell Fan | Early 19th century, probably Germany | 21.5 x 37.5 cm |
| 3-15 | | Spangled Black Lace and Ebonised Wood Fan | Late 19th century, Europe | 19 x 34.5 cm |
| 3-16 | | Polychrome Sandalwood Brisé Puzzle Fan | Late 18th century, Europe | 22 x 39 cm |
| 3-17 | | Appliquéd White Silk Gauze and Celluloid Fan | Probably 20th century, Europe | 31 x 40 cm |
| 3-18 | | Ostrich Feather and Tortoiseshell Fan | Early 20th century, probably France | 60 x 56 cm |
| 3-19 | | Porcelain-Handled Ostrich Feather Fan | Early 20th century, France | 60 x 35 cm |
| 3-20 | | Blue Iridescent Feather and Tortoiseshell Fan | 19th century, Europe | 34 x 53 cm |

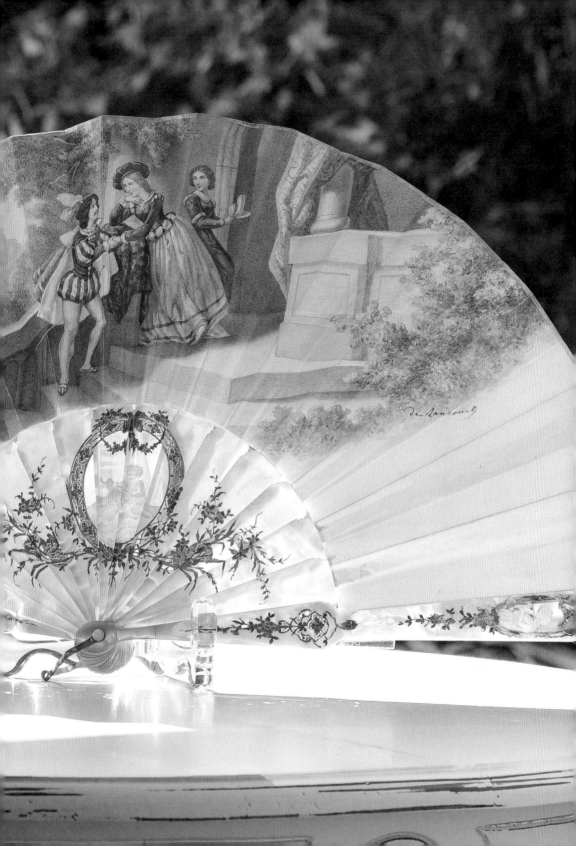

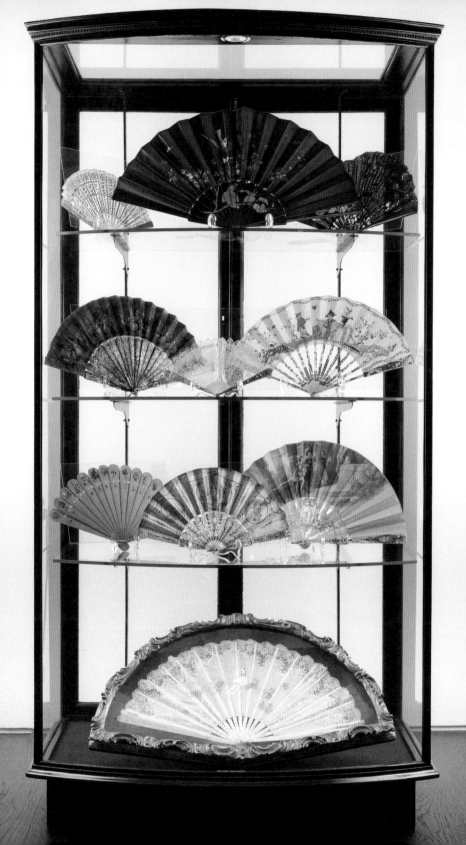

## About Eurus Collection

Eurus Collection, under the direction of Hahn Eura EunKyung, is a sister institution of Hwajeong Museum in Seoul. Since its foundation in 2017, it has been dedicated to researching antique fans as well as historical artefacts from the East and the West.

The collection maintains approximately one thousand fans in various forms and utilising multiple techniques from Europe, the USA, South America, China, Japan, Indonesia and Korea. It is a member of the UK's FCI (The Fan Circle International, 1975) and FANA (The Fan Association of North America, 1983) and is recognised by both associations. In addition, all fans in Eurus Collection have been professionally appraised by Gurr Johns International, New York, a company specialising in the appraisal and valuation of artworks. After undergoing appraisal by Gurr Johns International for two years, our fans' well-deserved value has been recognised.

Eurus Collection is the second largest of its kind in the world after The Fan Museum in Greenwich, London. Currently Eurus Collection is working on various exhibitions as well as educational and publication projects, striving to reach out to the general public by raising meaningful awareness of the value of fans and historical artefacts.

## About Hahn Eura EunKyung

Hahn Eura EunKyung is the director of Eurus Collection. Her work is dedicated to researching and writing about traditional arts and crafts following the wishes of the late Hwajeong (Dr.h.c. Hahn Kwang-ho), founder of Hwajeong Museum and Hahn Cultural Foundation. While her rigorous research aims to preserve the artefacts, as well as to advance the field of conservation studies, her wish is also to raise the status of fans as artworks through collaboration with international museums, galleries and collectors. Hahn Eura EunKyung works to preserve antique fans and raise awareness of the artistic value of fans for a wide audience through various exhibitions and publications.